# IMAGES
## *of America*

# MARIETTA

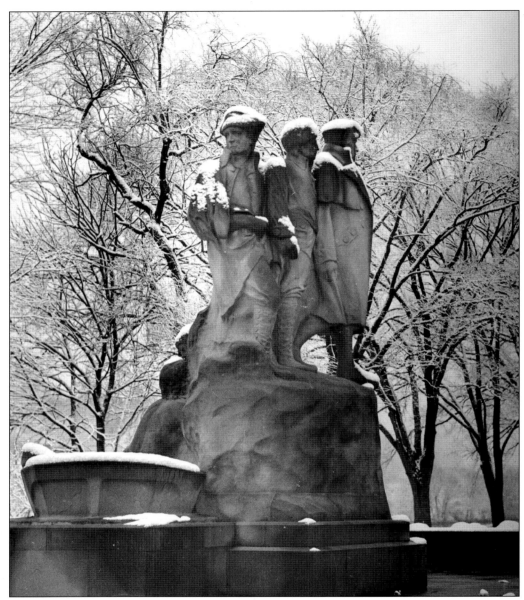

The Monument to the Start Westward, depicted in winter, flawlessly represents the harsh conditions the pioneers encountered as they confronted the wilds of the Northwest Territory. The monument, by designer Gutzon Borglum and architect John P. Schooley, includes four obelisks and a landing on the Muskingum River. The sculpture consists of three men standing atop a rock with a rowboat and two men and a woman behind them. They represent the first landing of the pioneers and the beginnings of westward expansion beyond the Allegheny region. The grouping depicts several figures in eighteenth-century dress. Two figures look toward the new lands of the west while the other looks toward the land left behind. The monument was erected in 1938 in Marietta on the site where Arthur St. Clair was inaugurated as the first governor of the Northwest Territory. It was part of the 150th anniversary of the Ordinance of 1787 and the opening of the Northwest Territory.

IMAGES
*of America*

# MARIETTA

Larry Nash White, Ph.D. and Emily Blankenship White

ARCADIA
PUBLISHING

Published by Arcadia Publishing
Charleston SC, Chicago IL, Portsmouth NH, San Francisco CA

Printed in the United States of America

Library of Congress Catalog Card Number: 2003114581

For all general information contact Arcadia Publishing at:
Telephone 843-853-2070
Fax 843-853-0044
E-mail sales@arcadiapublishing.com
For customer service and orders:
Toll-Free 1-888-313-2665

Visit us on the Internet at www.arcadiapublishing.com

*Dedicated to Bernard and Marjorie Blankenship*
*on the occasion of their 54th wedding anniversary.*

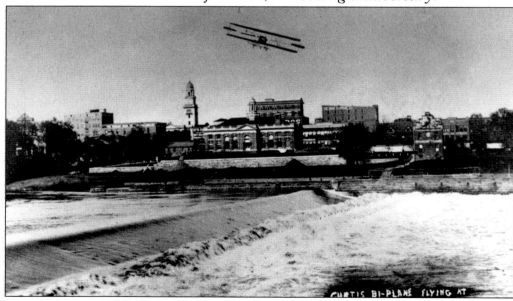

Flying high against the Marietta skyline, Lincoln Beachey, "the master birdman," visits Marietta for an aerial exhibition in May of 1912. Beachey's aerial career began in 1900, working with gas-filled balloons. Between 1905 and the time of his death at the Panama-Pacific International Exposition in San Francisco on March 14, 1915, Beachey had given aerial exhibitions in almost every state of the United States, as well as Canada, Cuba, Puerto Rico, and Mexico. In the last full year of his career, between November of 1913 and November of 1914, Beachey gave exhibitions in 126 cities and towns across the U.S., including Marietta. (WCHS.)

# CONTENTS

# ACKNOWLEDGMENTS

Without the following people this book could not have been accomplished. We thank them for their advice, expertise, and unending assistance:

The exceptional staff at the Washington County Public Library Local History and Genealogy Branch: Julia Engle, Eric Richendollar, and Catherine Sams. Special thanks are extended to Ernest Thode, manager of the Washington County Public Library Local History and Genealogy Branch, for his unending patience and extensive knowledge of Washington County History. The authors are also indebted to Charlotte Keim at the Marietta Area Chamber of Commerce for providing access to the riches in the Chamber archives. Lastly, we wish to thank Gary Brown and Dave Lenington at the Washington County Historical Society for granting access to their collection while it was undergoing relocation.

Thanks also to the following: Joseph Baker, John Briley, Beth Burlinggame, Marilyn Combs, Herbert Devol, Mary Jo Duncan, Ethel Gulotta, Nancy Hoy, Faith Perrizo, Robert Masters, and Lynn Shuman. And finally, thanks to Melissa Basilone, our editor at Arcadia, for giving us the opportunity to shine the spotlight on Marietta once again.

All photographs in this work are from the Washington County Public Library Local History and Genealogy Department Collection, unless otherwise noted. Photographs from the Marietta Area Chamber of Commerce are keyed "MACC." Items from the Washington County Historical Society Collection are keyed "WCHS."

# INTRODUCTION

The residents of Marietta, Ohio, have always been deeply proud of and concerned about preserving their cultural and architectural history. After all, Marietta was the first settlement in the Northwest Territories and has over 200 years of discovery, along with joys of fame and fortune, and sorrows of destruction and tragedy to preserve and share.

The extent of the passion of the residents of Marietta for preserving their history seems exemplified by a quote from Stewart Udall, Secretary of the Interior, in the July-August 1962 issue of *True West* magazine. Mr. Udall could have been speaking of the importance of the history of many of the influential past and present residents of Marietta when he stated, "History is the cumulative memory of mankind, and without it neither individuals nor nations can fully understand the present or wisely plan for the future. History shows us how much we owe to the past sacrifices of others. It kindles in us a quiet pride in the accomplishment of our forefathers and makes us determined to put the future in debt to us. This resolve is true patriotism without which no nation nor people can survive."

While conducting the research for this book, we identified many local resources of history. Marietta is extremely fortunate to have had influential residents throughout its extensive history that were conscious of the importance of collecting and preserving the written word and photographs as a valuable reference for contemporary use and historical posterity. It is due to these forward-thinking residents that we discovered a great wealth of preserved knowledge and information about Marietta and Washington County. In fact, the more treasures we discovered, the more we realized that we were just skimming the top of the apple barrel, to paraphrase a local colloquialism. Sadly, we were unable to include hundreds of photographs of endearing people and lovely homes, due to space constraints.

There are several notable residents whose efforts to preserve Washington County history have been invaluable. Residents such as Harry P. Fischer, the quiet, kind hearted photographer known for taking and giving great jokes, who captured over 40 years of history and lifestyles on film. Mr. Fischer was a true photojournalist whose work is exemplified in the photographs representing the early home and business scenes of Marietta.

When Harry Fischer closed his shop, Stephen Durward Hoag salvaged his priceless collection of over 14,000 prints, glass plates, and negatives. Mr. Hoag, ever boastful of Marietta and his Motor Hotel Lafayette, never missed an opportunity to share the vivid pictorial history of Mr. Fischer's works and his own, weekly, in the paid *Marietta Times* column "Round and Round Below the Railroad Tracks," which ran during the 1950s–1960s.

We must add that Mr. Hoag's two collies, Spud and Yampa Valley Hoag, often shared as much of the column's space as Harry Fischer's photographs.

Our last notable resident, Jerry Barker Devol was considered the ideal historian and preservationist. Jerry Devol's research was always right on the mark and never assumed or used second-hand knowledge. Without Mr. Devol's invaluable research, the inclusion of many of the photographs in this book would be impossible.

We hope you will enjoy this look at Marietta and Washington County in the years before Wal-Mart, I-77, and the internet. If you are one of the lucky recipients of this volume, we trust you will use it to preserve a piece of the Marietta and Washington County history. We hope that future generations will find our compilation has been worthwhile.

—Larry Nash White, Ph.D. and Emily Blankenship White

# One

# FINDING FORTITUDE

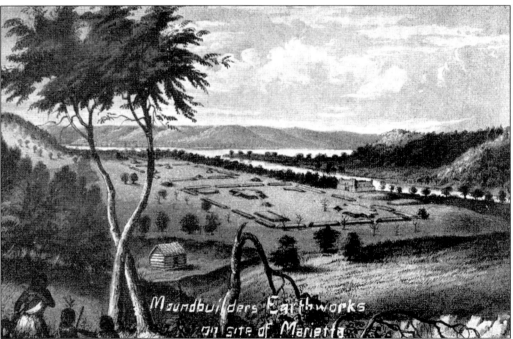

This early scene is from the hill north of Montgomery and Sixth Streets and depicts the future site of Marietta with earthworks as found by the pioneers. The log tannery in the foreground was owned by Ichabod Nye. Only three of the larger earthworks remain today: Conus in Mound Cemetery, Quadranaou in Camp Tupper, and Capitolium, the mound on which the Washington County Public Library currently resides. Theories have abounded about the purpose of the mounds. The two concurrent beliefs about the Marietta earthworks, built by the Moundbuilders of the Hopewell Indian culture, are that they were designed for the purpose of astronomical observation and charting, or that they were used as ceremonial centers of worship, and for bartering, family meetings, or burial.

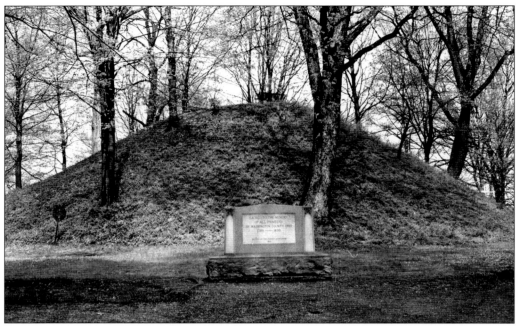

Conus Mound, bounded by Fifth and Sixth Streets and surrounded by Mound Cemetery, was built by the Hopewell Native Americans using bone and wood implements to scrape together earth into woven baskets to carry to the mounds. The name "Conus" was given to the pre-historic mound in Mound Cemetery by the early settlers because of the exactitude of its dimensions and its symmetrical construction; it stands 30 feet high with a 375-foot diameter. The moat is 15 feet across and 4 feet deep. Twenty-four officers of the American Revolution are buried in Mound Cemetery, including General Rufus Putnam, General Benjamin Tupper, and Commodore Abraham Whipple. (MACC.)

On the west bank of the Muskingum River at its junction with the Ohio River, Fort Harmar was built in 1785 by a detachment of United States troops. The troop's purpose was to move "squatters" from the land and to make a presence known to the Native Americans. A well was dug for the garrison near the midpoint of the parade grounds. In 1963, this well was discovered near the middle of the Ohio River. Fort Harmar's site eroded away just as Jamestown and other founding cities also disappeared.

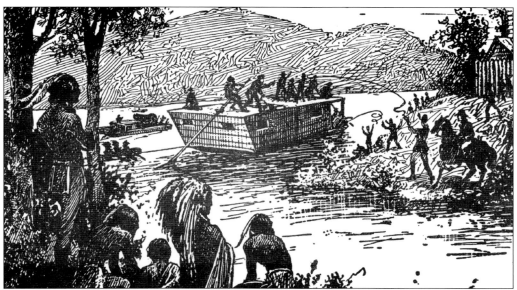

The establishment of the Northwest Territory and Marietta are attributed to the Ohio Company's party of 47 pioneers who landed on the east bank of the Muskingum River on April 7, 1788. The pioneers left Ipswich, Massachusetts, on December 3, 1787 and arrived at Sumrill's Ferry, Pennsylvania, on January 23, 1788. Boat-building commenced in the latter part of February. Under the direction of Captain Devol, a large galley with a 50-ton capacity was constructed, as well as a flatboat able to carry three-tons and three dugout canoes. The flotilla left Sumrills' Ferry on April 1. They spent April 6 at Round Bottom, about 70 miles above Marietta. They left Round Bottom at dusk the same day in order to reach Fort Harmar at the next midday.

This list shows 48 men arriving on April 7, 1788, when actually there were 47. Colonel Return Jonathan Meigs Sr. came on horseback, arriving April 12. According to recorded comments of the time, including journals of Sergeant Joseph Buell, the flotilla of the pioneers on the *Adventure Galley* missed the fort and had to be towed to the east side of the river. At the fort was a band of Delaware and Wyandotte Native Americans, led by Delaware Chief Captain Pipe, to trade with the pioneers and soldiers. (WCHS.)

## Marietta's original 48 pioneers

- Gen. Rufus Putnam,
- Return Jonathan Meigs Sr.
- Col. Ebenezer Sproat.
- Maj. Anselm Tupper.
- John Matthews.
- Maj. Haffield White.
- Capt. Jonathan Devol Jr.
- Josiah Munro.
- Capt. Daniel Davis.
- Peregrine Foster.
- Jethro Putnam.
- Capt. William Gray.
- Capt. Ezekiel Cooper.
- Phineas Coburn.
- David Wallace.
- Gilbert Devol Jr.
- Jonas Davis.
- Hezekiah Flint Jr.
- Josiah Whitridge.
- Benjamin Griswold.
- Theophilus Learned.
- William Miller.
- Josiah White.
- Henry Maxon.

- William Moulton.
- Benjamin Shaw.
- Jervis Cutler.
- Samuel Cushing.
- Daniel Bushnell.
- Ebenezer Corey.
- Oliver Dodge.
- Isaac Dodge.
- Jabez Barlow.
- Allen Putnam.
- Joseph Wells.
- Israel Danton.
- Samuel Felshaw.
- Amos Porter Jr.
- John Gardner.
- Elizur Kirtland.
- Joseph Lincoln.
- Earl Sproat.
- Allen Devol.
- William Mason.
- Simeon Martin.
- Peletiah White.
- Hezekiah Flint Jr.
- Edmund Moulton.

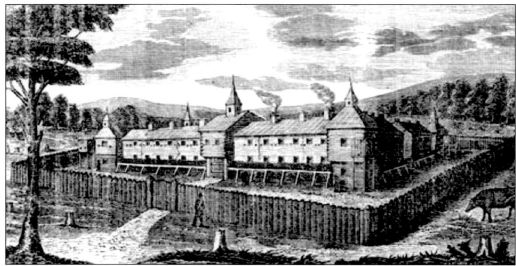

In 1788, under the supervision of Jonathan Devol, shipwright and master builder, Campus Martius (translated literally means "a field dedicated to Mars, the god of war") was constructed in the area of what is now Washington and Third Streets. It was designed as a 180-foot square of dwellings to accommodate 50 to 60 families. Yellow popular was hewn by whipsaw into floor and wall boards. Windows were covered with oiled paper. Legend says that the Native Americans never attacked the fort for fear of the sacred golden rays that bounded off the fort's walls. The Ohio Company Associates set aside the southwestern blockhouse in a futile effort to entice territorial Governor Arthur St. Clair to make Marietta the capital of the Northwest Territory. The southeastern blockhouse was reserved for entertainment, the northeastern blockhouse for the Ohio Company meetings, and the northwestern blockhouse for religious services.

The Ohio Company Land Office was constructed in 1788 and is the oldest building in the Northwest Territory still standing. From its location on what is now Second Street, the sale and allotment of lands were conducted, maps were drawn, and surveys made under the direction of the Surveyor General of the United States, Rufus Putnam. In 1953, the entire structure was restored and moved onto the Campus Martius Museum property.

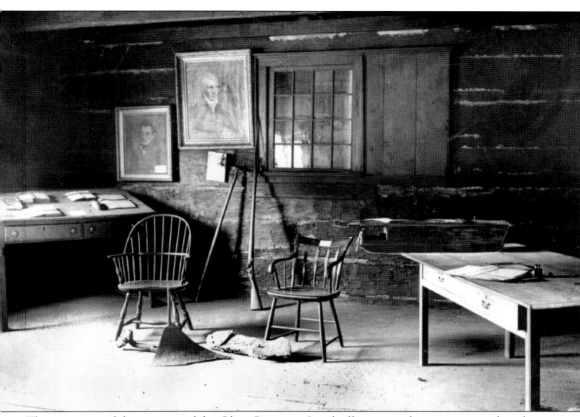

This is a view of the interior of the Ohio Company Land office soon after it was moved to the Campus Martius Museum. Inside the building were a model of the *Adventure Galley*, portraits of Return Jonathan Meigs and Rufus Putnam, original Ohio Company of Associates documents, a plow, a chair from Rufus Putnam's house, a muzzle loader, and a chair from the Blennerhasset mansion. Today, many of these, as well as additional pioneer items, are on display at the Campus Martius Museum, 601 Second Street, Marietta.

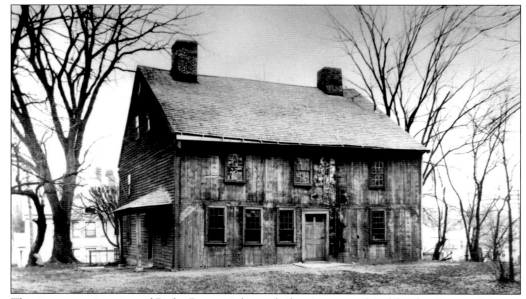

This is an exterior view of Rufus Putnam's house before it was enclosed by the Campus Martius Museum. This house had been part of the fortress of Campus Martius. The fortress had consisted of 13 two-story houses arranged in the form of a hollow square, which measured 180 feet on a side. The timbers, hewn in pre-determined shapes, were stamped with Roman numerals, and by matching corresponding numbers the artisans were able to assemble the timbers into complete and substantial structures.

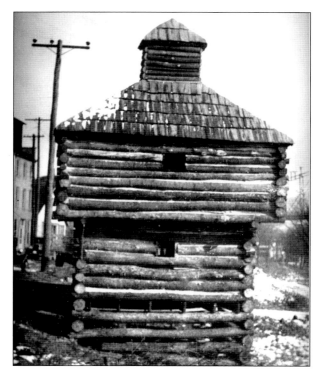

Blockhouses at each corner of the Campus Martius square were constructed with a projecting upper story. Holes were cut in the projecting floor for showering bullets on Native American attackers. The blockhouses were built at the expense of the Ohio Company. The carpenters made 50¢ a day and one ration. Laborers made $7 per month and one ration per day. When completed, the Campus Martius structure contained 72 rooms. This blockhouse was constructed in 1937 by Reno and Durwood Hoag for the Northwest Territory Celebration of 1937.

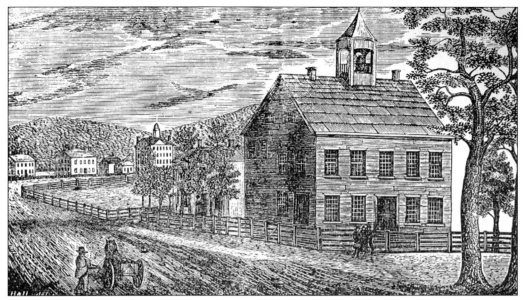

The first Washington County court session was held at the home of Eben Battelle, and the second was held in the Northwest blockhouse of the Campus Martius. The first court house building funds were appropriated in 1798. Supervising the building of the court house were Dudley Woodbridge and architect David Greene. The court house walls were three feet thick, made of hewn yellow poplar logs. The building was two stories high and consisted of four rooms.

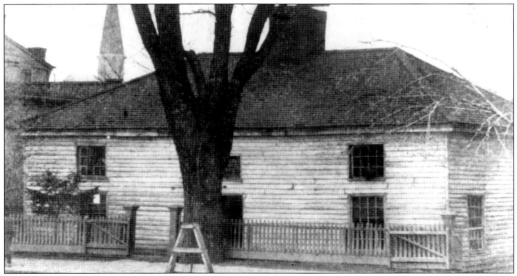

This is an early view of Muskingum Academy, which was built on Front Street in 1797, just north of the Two-Horned Church. It was used until 1832 and then was a residence until 1887. The spire of the German Methodist Church shows at left. Marietta College was established in 1835. It is considered the lineal descendent of Muskingum Academy. In its lifetime, Marietta College has absorbed Elizabeth College, established in 1890 by Professor John Mills, and the Marietta College for Women. Its more immediate parents were the Institute of Education, established in 1830, and the Marietta Collegiate Institute and Western Teacher's Seminary, established in 1832.

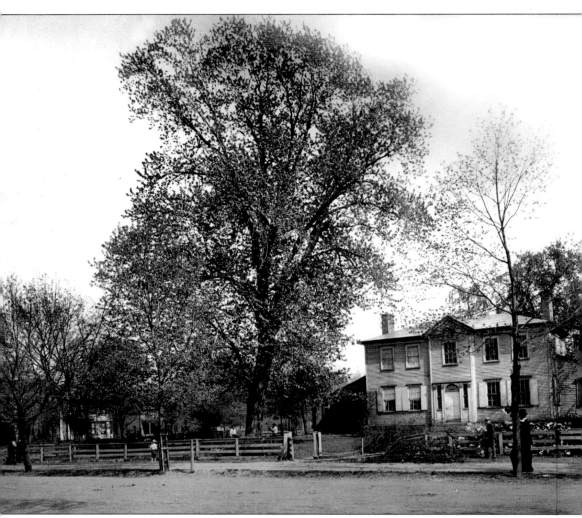

The old Woodbridge Place, in the square bounded by Putnam Street, Butler, Second, and Third streets, was built in 1806 on lot number 687. The house was taken down and moved out of town between 1885 and 1890. The Woodbridge family came to Marietta from Norwich, Connecticut, in 1788. Dudley Woodbridge Sr. and his wife Lucy opened what was probably the first retail store in Marietta in a log cabin near the Ohio River. Their son, Dudley, later went into the mercantile business with his father.

# Two

# PUTTING DOWN ROOTS

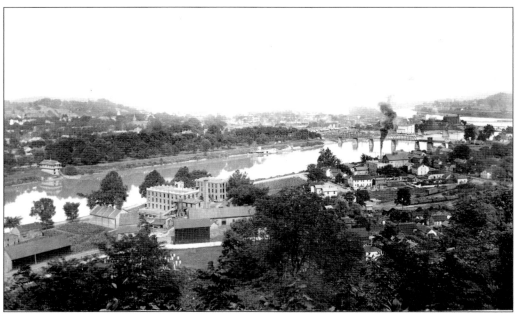

This spacious view, *circa* 1912, from Harmar Hill overlooking the Muskingum River gave pleasure to the residents then as it does now. In 1825, when Marietta received its charter, Harmar was considered the city's second ward and part of the corporation. However, by 1835, Harmar residents had grown dissatisfied, and they separated from Marietta to become a village, retaining this status for more than 50 years. As the city began to grow in the late 1800s, unification appealed to the two municipalities. In 1887, the Board of Trade, a precursor to the Marietta Area Chamber of Commerce, promoted the idea of reuniting the two halves of the city. In April 1890, the voters of Harmar Village decided to reunite with Marietta by a 90-vote margin.

The Henry Fearing house, built in 1847, features traditional Georgian architectural features. Georgian architecture is one of the many varieties of architecture appearing in Marietta. Henry Fearing was the son of Paul Fearing, the first lawyer in the Northwest Territory. Fearing lived in this house until his death in 1894. In 1974, the Washington County Historical Society purchased the house from David and Shirley Morris and began a full restoration. This house is now open for tours on weekends May through October from 1 to 5 p.m.

Josiah D. Cotton built his two-story Greek Revival brick house at 412 Fifth Street in 1853. The beautiful home has gallery porches on either side. Josiah D. Cotton graduated from Marietta College in 1842. Josiah studied medicine in New Orleans and at Ohio State University before receiving his degree at the University of Louisville, Kentucky. In 1847, upon his father's death, he returned to Marietta to practice medicine. The Cottons' daughter, Willia, was Marietta's librarian for over 30 years.

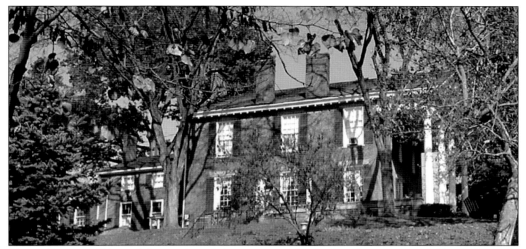

Henry Pierson Wilcox, Marietta's eighth postmaster built this Georgian- and Greek Revival-influenced home at the corner of Fifth and Putnam streets in 1822. Colonel John Mills, a banker and the treasurer of Marietta College, purchased the house in 1836. His sons John and William lived in it until 1937. The basement walls are 24 inches thick, and the timbers in the structure are hand hewn, mortised, and secured with tendons. The elegant stairway features a shelled dome. Since Marietta College assumed ownership, this house has served as the residence of the Marietta College president. The home is also included in the National Register of Historic Places.

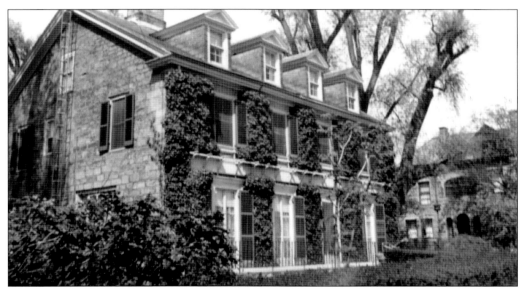

David Putnam Sr.'s home at 519 Fort Street was completed in 1805. David Putnam was the son of Colonel Israel Putnam of Belpre. Seven generations of the Putnam family owned and lived in the house. This sandstone building also housed Ohio's first bank, chartered in 1808. Rufus Putnam was the bank's first president. David Putnam was the director and cashier. In the 1930s, the house passed to the Equitable Life Assurance Society of the United States. Since the 1980s, the house has been carefully preserved through various owners as an example of Federal Period architecture in Marietta.

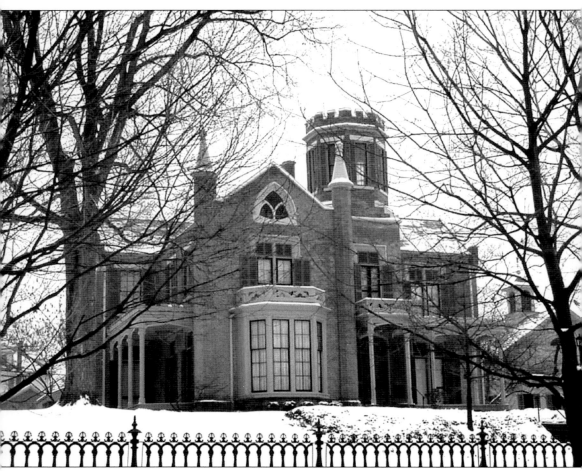

Melvin Calvin Clarke purchased his property on May 18, 1855. In 1860, he left to fight in the Civil War. He lost his life at the battle of Antietam. On June 21, 1858, John Newton purchased the house for $10,800 from Melvin Clarke. Edward White Nye, Marietta newspaper editor, bought the house in 1887 from the Newton estate. Upon his death in 1888, his widow inherited the property and later deeded the house to her daughter, Lucy Nye Davis. Lucy, in turn, deeded the house to her eldest daughter, Jessie Davis Lindsey, who lived there until five days before her 100th birthday. In 1974, the Castle was purchased by Stewart Bosley and his sister, Bertlyn. Following the death of Stewart in 1991, the Castle was deeded to the Betsey Mills Corporation as an "historical asset" for Marietta. The celebrated Castle is seasonally open to the public for tours, exhibits, and special events.

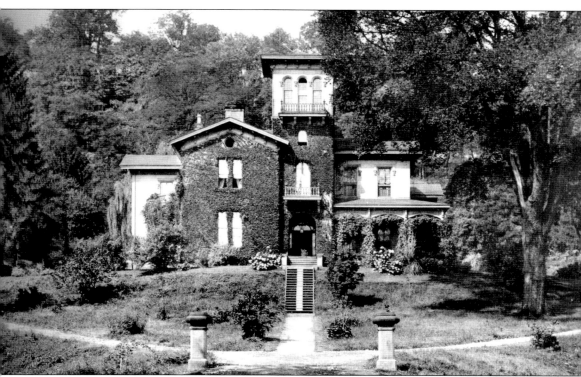

The most striking home in Marietta is the imposing ashlar sandstone Italian villa known as the Anchorage or Putnam Villa. This home, built in 1859 by Douglas Putnam for his wife Eliza, comprises 22 rooms and a grand tall campanile that fronts the house. From the tower room, the largest part of Marietta and its two rivers can be viewed. John Slocomb was the architect and master builder. The walls are made of 24 inch thick sandstone, quarried from the top of the hill behind the house. The foundation is of solid rock and all of the wood used in the house is locally grown oak. It is said that the frugal Douglas Putnam regretted having built the house. The Anchorage is best remembered as Edward MacTaggarts residence. Using wealth accumulated from oil wells in Oklahoma, Mr. MacTaggart restored the home and furnished it with treasures from his many worldwide travels. The Anchorage is currently owned by the Washington County Historical Society and is awaiting restoration.

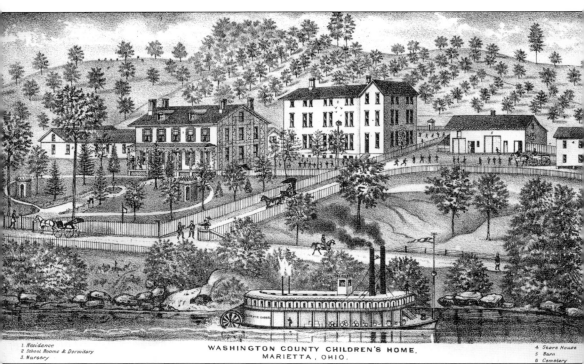

WASHINGTON COUNTY CHILDREN'S HOME,
MARIETTA, OHIO.

In the fall of 1853, Catherine Fay Ewing witnessed the death of an orphan child who she had considered caring for, but could not. She was so moved by this death that she assumed a teaching position in Kentucky and saved enough funds, along with two legacies, to allow her to purchase land and a home large enough to care for nine orphaned children. Mrs. Ewing established the first Children's Home of the county and of the Northwest Territory. The home was located on a 12-acre farm, about ten miles east of Marietta at Moss Run. Mrs. Ewing met considerable opposition for her efforts. She was ostracized, her chickens killed, and the livestock turned out. To overcome the difficult school situation, she established a school in the home with one teacher. Mrs. Ewing lobbied the Ohio legislature along with State Senator Samuel Knowles. They fought for and won public tax support after several years of failures. In 1866, a law was passed permitting children's homes to be established in every county. In 1866, land on Muskingum Drive in Marietta was purchased and construction begun for a permanent Children's Home, which opened in 1867. The home closed in 1974 after the legislature implemented foster care in place of group children's homes.

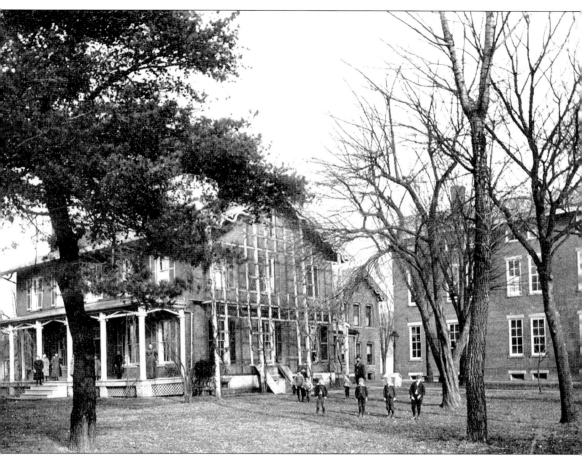

Washington County was the first to take advantage of the new funding law for children's homes and purchased a 100-acre farm designated to be the Washington County Children's Home. In April 11, 1867, 25 children were moved from Catherine Ewing's farm home to the new Children's Home on Muskingum Drive. This home often housed as many as 100 children at once. The home was phased out in the mid-1970s and replaced by foster homes. Today, the second floor of the girl's wing houses the Washington County Historical Society Archives. The Washington County Department of Health and the Washington County Addiction Recovery Board are also located in this two-story labyrinth. Behind the home, in the Washington County Children's Home Cemetery on Prospect Hill, lie the remains of 78 children who died at the home between 1867 and 1923. Legend also states that the home's three Shetland ponies, Midget, Lady, and Pat, who died in the home's 1928 barn fire, are also interred in the cemetery.

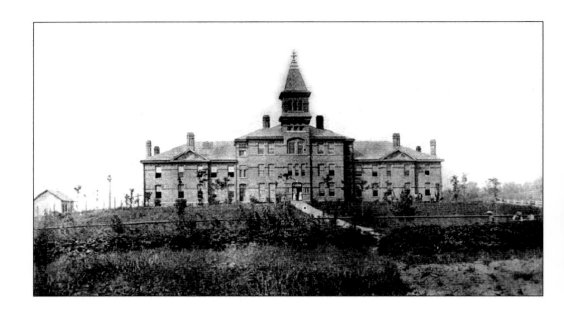

In 1838, a farm was purchased about two miles east of Marietta for a Poorhouse, or as it was called after 1851, the "County Infirmary." During the first 50 years, about 100 residents lived there at any given time. The residents kept busy performing daily chores, including maintaining gardens, cooking, and keeping cattle. The residents also canned and made apple butter in season. Construction began on a new facility in 1974, and the residents moved into the new home in 1977. The infirmary cemetery still exists behind the home, although only four tombstones remain. Cemetery records are non-existent. Legend states that they were stored in a tool shed and were later burnt to make room for a lawn mower. The top photograph shows the county infirmary *circa* 1915. The bottom photograph is *circa* 1980.

Martin Wells built this house at 316 Third Street in 1868. The Bosworth family then lived in this home for 17 years. Welles Bosworth, one the two sons of Daniel P. Bosworth, was an architect who worked on the restoration of Versailles and lived at Villa Marietta near Paris, France. Welles is well remembered in Marietta for donating the steps for Erwin Hall at Marietta College. In 1897, the house was acquired by oilman Frank B. Biszantz. The Biszantz heirs sold the house to the City of Marietta, who in turn sold it to the Marietta Area Chamber of Commerce, who makes its home there today. (MACC.)

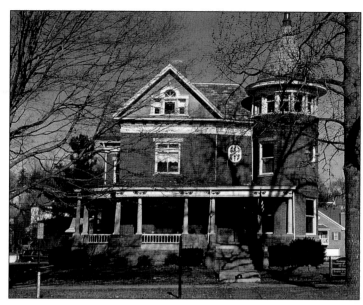

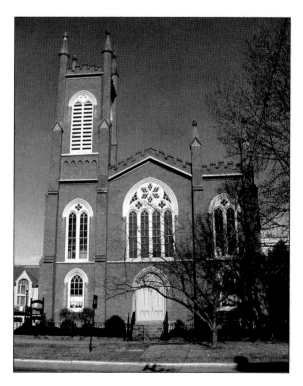

One of the finest examples of Gothic architecture in Southeast Ohio is the First Unitarian Universalist Church located at 232 Third Street in Marietta. The church congregation was originally formed by Nahum Ward and several friends in 1855 as the First Unitarian Society of Marietta. The church building was completed in 1857. Mr. Ward paid the total building price of over $25,000 and then deeded the church and the land to the congregation for $1 at the dedication ceremony. All of the cornices, window sills, and door casings are made of heavy cast iron. The hand-carved front interior stairway was made by a former slave who had won his freedom through his craftsmanship. The clay for the handmade bricks came from long earthen walls constructed by the Hopewell culture. These parallel walls formed a sacred passage (Sacra Via) that once lead to the Muskingum River through what is now Sacra Via Park.

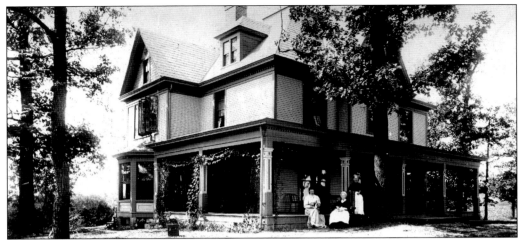

Jesse Palmer built a lovely, large home at 306 Fairview Avenue on Harmar Hill in 1897. Residents of the grand old home enjoyed summer breezes coming up the hill from the Muskingum River. The home was destroyed by fire 70 years later. This photograph was taken on March 3, 1898. Jesse's wife Saida Scott Palmer is sitting in the center of the photograph. The other visitors are unidentified.

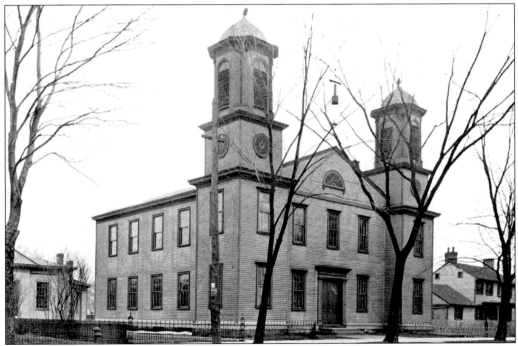

The oldest congregation in the Northwest Territory is the First Congregational Church. The church organized with 31 members on December 6, 1796. Mr. Daniel Story, formerly of the Ohio Company, was asked to become the first pastor 16 months later. The building was dedicated on May 28th, 1809. For the first 13 years, the church had no heat except for small foot stoves. This photograph was taken before the Two-Horned Church was remodeled in 1901. The building was destroyed by fire in 1905. A new brick church was built on the same ground soon after.

When the Ohio Company arrived from New England to settle Marietta, they brought with them the Church of England's *Book of Common Prayer*. It is reported to have been used for the first religious services in Campus Martius. It was not until 1826 that Judge Arius Nye organized the parish of St. Luke's, where he served as lay reader for the next seven years. John Slocomb of Anchorage fame was the church's designer. Built in 1856, St. Luke's Episcopal Church reflects the Gothic Revival style.

The first German Lutherans in Marietta came together for home worship. In 1858, the First Evangelical Lutheran Church was formed and members worshipped in the church vacated by the St. Luke's Episcopal Church. In the 1890s, the Reverend K.F. Theime introduced the English language into the church services, replacing the German language. The building of the present church occurred in 1901, using local green fieldstone. The altar piece is a replica in wood of Leonardo Da Vinci's *The Last Supper*. An addition, also of green fieldstone, was dedicated on April 26, 1992.

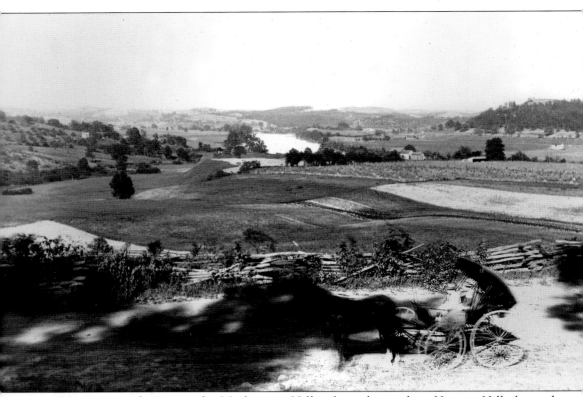

"Here's a grand view up the Muskingum Valley from the road up Harmar Hill above the stone quarry," wrote Professor Thomas Dwight Biscoe on September 18, 1886. In addition to teaching geology, mineralogy, chemistry, and physics at Marietta College, Professor Biscoe spent over 40 years in service for the United States Weather Bureau, painstakingly recording the Marietta weather record. Ever the meteorologist, he reported in detail that it was 3 p.m., clear, and sunny when he took this picture. This report is from Professor Biscoe's notes, attached to the original photograph.

## Three

# ROUND 'N ROUND DOWNTOWN

It was apparent that Marietta had outgrown its first courthouse by 1819. Return J. Meigs, Levi Barber, and D.H. Buell comprised a committee to advertise for plans for a new courthouse. The advertisement was announced in 1821. After the announcement of the location of the new courthouse, the citizens of Marietta rose up in opposition. The location changed five times before construction commenced. The final location was a lot donated by Ebenezer Sproat. The building was completed in 1823. An addition on the north side of the courthouse was completed in 1854. A new front addition to the building was added in 1879.

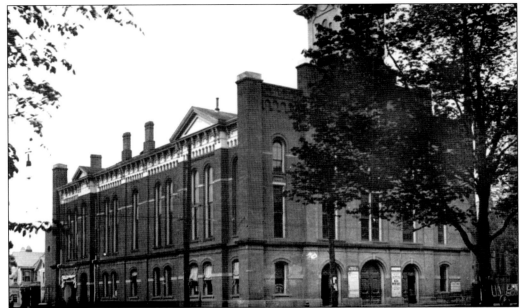

The City Council decided to erect a substantial brick building in 1871 to accommodate city officers and the fire department and to provide a general meeting place. W.W. McCoy won the contract for the building in September 1871. McCoy's planned building proved to be too small before construction commenced, so a larger contract was awarded in October 1871. Work on the new building finished on February 1, 1893, at a cost of $70,000. The formal opening of the city hall auditorium was held on February 4, 1893, with a presentation of Buelwer's *The Lady of Lyons*. The auditorium seating capacity of 1,500 was enlarged in 1894 at a cost of $17,000. The entire building burnt on November 11, 1935, when an intoxicated inmate set fire to the ceiling above his cell.

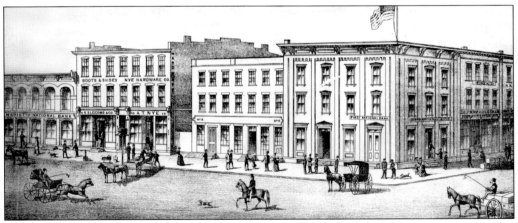

The Marietta National Bank stood at the corner of Front and Greene Streets in 1875. I.R. Waters served as president of the bank. Next door at 12 Front Street stood S. Slocomb and Sons, dealers in boots and shoes. Nye Hardware stood at 10 Front Street and the First National Bank of Marietta stood at the corner of Front and Greene Streets with Beman Gates serving as president. Next door at 2 Greene Street was Shipman, Holden, and Co., "dealers in staple and fancy dry goods and notions."

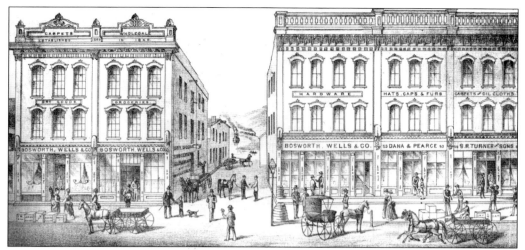

The Bosworth and Wells Company, built in 1840, stood on the southwest corner of Front and Monroe Streets. The Bosworth business occupied three storefronts, at 47, 49, and 51 Front Street. The Bosworths dealt in dry goods, groceries, and hardware. In later years, the Bosworths were among the pioneers to deal in "Seneca Oil," which was discovered in the Macksburg-Lower Salem region. Seneca Oil was used to treat rheumatism. Dana and Pierce, dealers in furs, hats, and caps, kept business at 53 Front Street. Next door, at 55 Front Street, was S.R. Turner and Sons, dealing in dry goods, carpets, and oil cloths. Fire destroyed this section of Front Street on December 28, 1946.

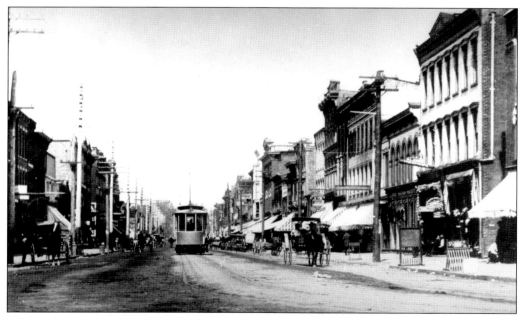

Vendor signs also doubled as hitching posts, as seen in this 1897 view of Front Street. Buggies and carriages are parked wheel to wheel in this scene of prosperity. One of Marietta's street cars passes along Front Street headed toward Greene Street. The street car tracks were installed in 1896. Notice that this is a pre-street arch scene. Eighteen steel arches were installed in 1898—coinciding with the opening of the Municipal Light Plant.

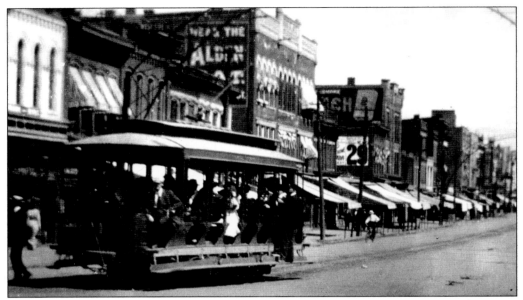

Open-air streetcars rolled along Marietta's streets in 1914. This scene is at Front and Putnam Streets. Marietta's buildings served as large billboards in its heyday. In 1924, the street arches, seen here above the trolley, were removed by employees of Lyle H. Scott, the famous local aviator. Mr. Scott purchased the old city arches to be used for building airplane hangers around Ohio. The arches from Greene and Front Streets were taken to Zanesville and erected on a farm used as an airfield for Mr. Scott and his three airplane flying circus.

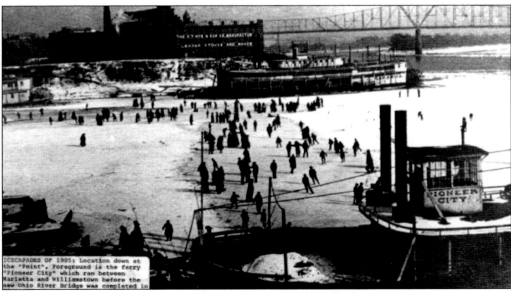

ICECAPADES OF 1905: Location down at the "Point". Foreground is the ferry "Pioneer City" which ran between Marietta and Williamstown before the new Ohio River Bridge was completed in

The citizens of Marietta present the ice capades of 1905. This photograph was taken looking toward the "Point." In the foreground is the *Pioneer City*, which ran between Marietta and Williamstown before the new Ohio River Bridge was completed in 1903. The steamboat anchored at the Point is the *Kanawha*. Far behind, past the A.P. Nye and Son stove works, you can see the tower of the Bellevue Hotel.

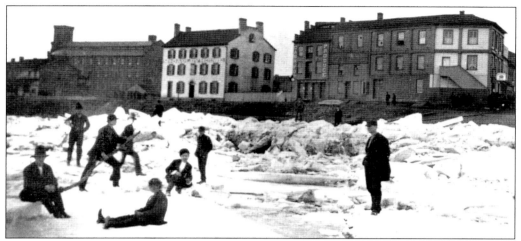

In January 1884, the Ohio and Muskingum Rivers froze so hard that ice gorges formed, destroying any and all wooden vessels caught in the flow. In this picture, taken near the Ohio River levee, adventurers enjoy the arctic landscape. The building on the right is where the Lafayette Hotel now stands. The white building in the center is the McCauley House Hotel, otherwise known as the Mansion House and later, the St. Charles Hotel.

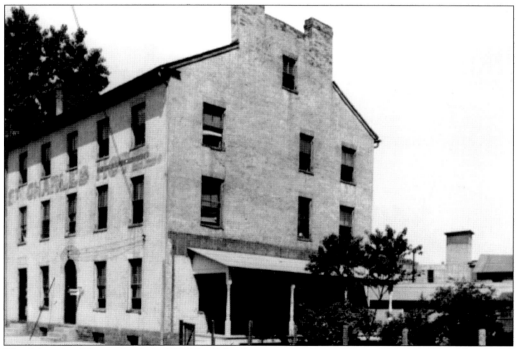

The Mansion House, built in 1835 by John Lewis, served as a House Hotel on Post Road, the oldest street in Marietta. In 1840 it was considered Marietta's finest hotel. After many years of popularity, it fell into disrepair. It was renamed the St. Charles Hotel and was purchased in 1937 by Reno G. and S. Durward Hoag, who owned the Lafayette Hotel next door. The house was acquired from Thomas and Harry McCurdy. The house stood directly behind the Lafayette and was demolished to build a 30-room addition, called the Hoag Addition.

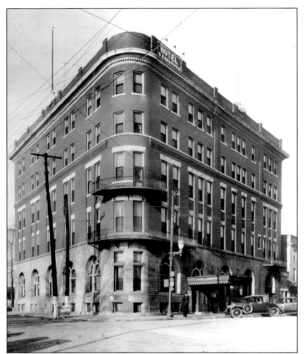

This photograph shows the Lafayette Hotel *c.* 1935. The hotel was built by Marietta businessmen. It opened on July 1, 1918, and was incorporated as the Marietta Hotel Co. Reno G. Hoag was hired as manager with a salary of $150 per month plus room and board for his family. When Mr. Hoag was named manager in 1918, his 18-year old son S. Durward Hoag also began working for the hotel. For a number of years, Reno and Durward bought stock, as it was offered to them, and in 1924, incorporated. Together they operated the Lafayette, making improvements and changes as the times dictated. Reno Hoag died on March 4, 1944, and S. Durward Hoag continued to run the hotel until he sold it, on December 17, 1973, to local businessman Harry J. Robinson.

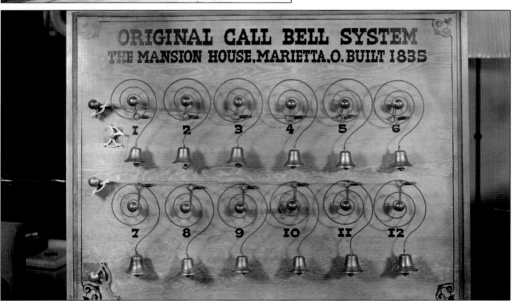

This is the original call-bell system from the Mansion House. A dozen small bronze bells, numbered and suspended on coil springs, were activated by pulling a cord placed in each guest's room. The bell would vibrate on its spring for several minutes so the maid could see what chamber was calling for her. Reno Hoag and his son found this system before the old Mansion House was demolished. They rehabilitated the system for display in the Lafayette Hotel. The bells and other parts of the system were made in England. Similar systems were used in English inns in the seventeenth century. The bells remain on permanent display today at the Lafayette Hotel.

Prior to the building of the Lafayette Hotel, the Bellevue Hotel stood at the corner of Front and Greene Streets. The Bellevue was also built by the Marietta Hotel Co., a group of local citizens who believed Marietta needed a first-rate hotel in the business section of Marietta. The Bellevue opened for business in 1892. The Marietta Hotel Co. leased the building to various operators over its 24-year life span. The Bellevue was the first hotel in Marietta to have an elevator. It also featured hot and cold baths. It had 55 rooms, a barber shop, and a bar. Rates were $3 per day, including meals. It suffered a devastating fire on April 26, 1916. The hotel was rebuilt and opened as the Lafayette Hotel in 1918.

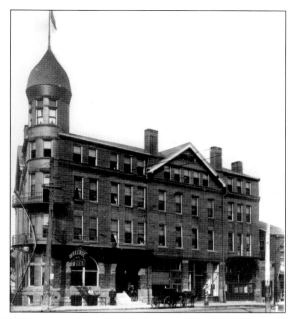

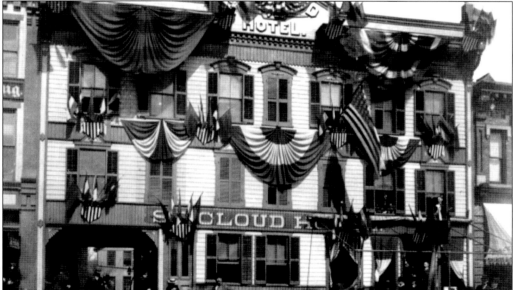

The St. Cloud Hotel constituted one of Marietta's best-known hostelries for over 80 years. Owned and built in 1861 by Mrs. Gross, J. Frank and S.A. Coffman purchased the St. Cloud in 1920. The wood structure was demolished, and a brick four-story building was raised in 1890. The hotel was remodeled, and all rooms were equipped with baths, running water, and electric lights in 1922. The hotel boasted modern dress and equipment enjoyed by the traveling public. On January 15, 1939, the hotel experienced an extensive fire on the fourth floor when a faulty gas stove pipe caught fire. Many of the 95 rooms in the brick structure suffered water damage, and the hotel ended up being renovated. At this time proprietors J. Frank and Mrs. Birdie Coffman installed steam heat throughout the building. This view is of the St. Cloud Hotel, 192–194 Front Street, decorated for Marietta's Centennial on April 7, 1888.

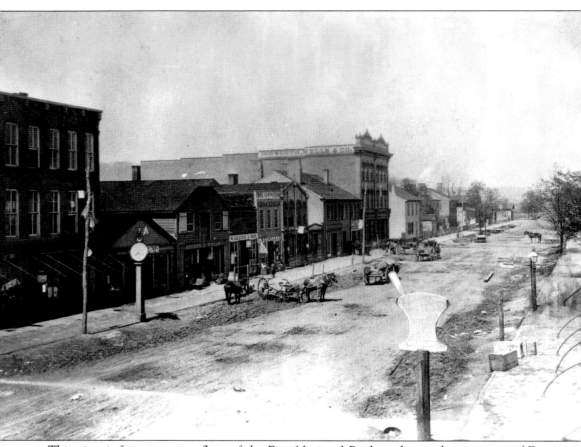

This view is from an upper floor of the First National Bank at the northeast corner of Front and Greene Streets in Marietta *c.* 1860. In the right foreground is a mortar-and pestle sign that reads, "Buell & Bro. Druggist." Below the sign is a foot bridge spanning a drainage ditch. All of the awning coverings have been removed, suggesting an early spring scene. The wheels of the wagons are also up to their spokes in mud. The Bosworth, Wells, and Co. dry goods, clothing, and grocery firm is the large store in the center of the photograph. Successors in the same location were Penrose and Simpson, until 1903, and L. Gruber and Sons, until fire destroyed the building in 1946. Other stores in this photograph are George Wells' store, William Glines' book and stationery store, Gerd Wendelkens' groceries and dry goods, L.S. Brown's Gent's Furnishings, and Geo. Jenzey books. (WCHS.)

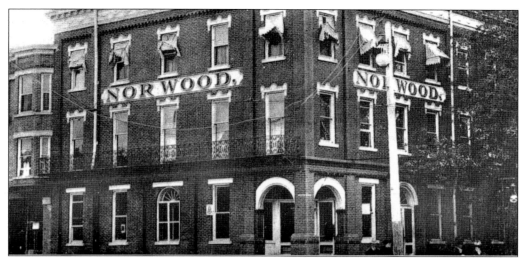

The Norwood Hotel stood at the corner of Second and Greene Streets. It was established in 1900 as a 65-room hotel rebuilt from the old National House. The annex was built in 1902. The hotel closed in 1918. In 1919, the Light and Traction Streetcar Company bought it and converted it and the annex into a terminal and freight office for the Parkersburg-Marietta Inter-Urban Rail System. In 1925, the Norwood was torn down but the annex remained in use as a terminal and freight office. In 1947, when the Parkersburg-Marietta interurban cars ceased operating, the annex was sold to Charles Ferguson and Major A.W. Sherwood. From 1947–1974, the annex was used for a number of purposes. In 1974, the annex was torn down. (WCHS.)

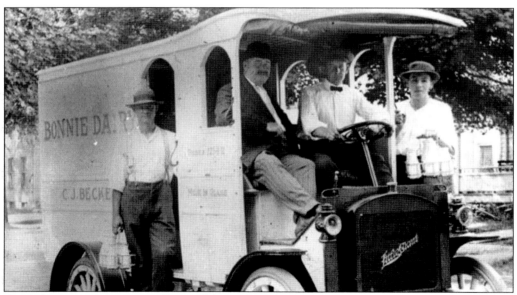

Around 1914 in Marietta, milk was delivered in glass bottles by the Bonnie Dairy, owned and operated by C.J. Becker. The dairy was located, according to the 1914 Marietta City Directory, on Rathbone Terrace, which was out in the country. From left to right are John H. Craig, C.J. Becker, W.W. Covey, and David Hockenberry. The milk truck is a Little Giant brand truck. Quarts of milk were delivered for 6¢ apiece. Little Giant trucks were only manufactured in 1910. They had a dual chain drive and hard rubber tires. The motor, under the seat, was known to cut out frequently.

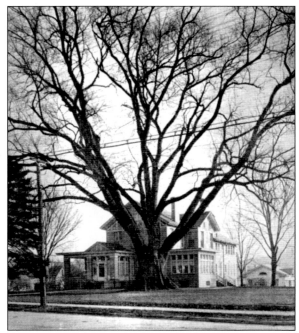

Not far from the Bonnie Dairy stood the Rathbone Elm on Muskingum Drive. In the 1940s it was thought to be the largest spreading elm in North America. The tree's ground span was 50 feet, and it stood 105 feet tall. At over 500 years of age, in the 1950s, the tree fell victim to the Dutch elm disease. The tree was cut back to a 20-foot section in 1958 and protected in cement, but it succumbed to the disease within a year. Coffee table tops, candleholders, and other souvenirs were made of its limbs.

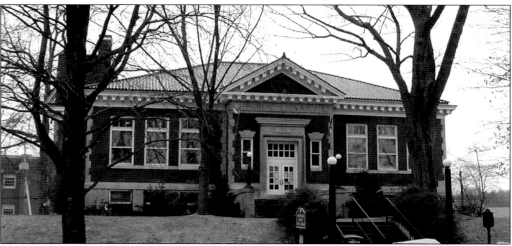

Around 1796, the private library of Colonel Israel Putnam became the nucleus of what is considered to be the first public library in the Northwest Territory. On July 3, 1829, a meeting was held at the home of Colonel John Mills for the purpose of taking into consideration the best method of establishing a circulating library in Marietta. Many early Marietta citizens attended, including John Cotton, John Mills, A.T. Nye, Douglas Putnam, David Putnam Jr., D.P. Bosworth, Samuel Shipman, Dr. Jonas Moore, Dr. S.B. Hildreth, and Arius Nye. The permanent site of the library was finally chosen after moving numerous times to temporary new locations. The final building site was the "elevated square," called Capitolium, near Fifth and Washington Streets. The library was built after Andrew Carnegie pledged $30,000 for library construction, the city provided the lot and monies for operation, and public donations yielded $4,000. George Walter Hovey was the architect of the new library and Levi Cowell, the contractor. Construction began during the summer of 1916 with the building completed in 1918.

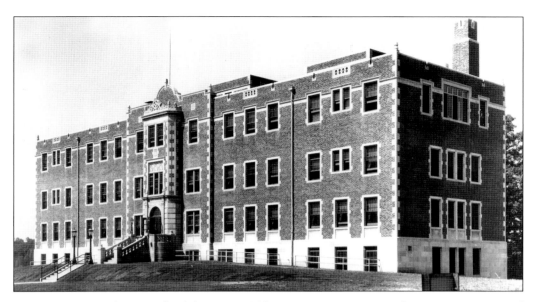

Marietta Memorial Hospital celebrates its 75th anniversary in 2004. The Marietta Memorial Hospital Corporation, under the direction of B.F. Strecker, was formed in 1921 by a group of local citizens who saw a need for a large, centralized health care center in Marietta. After an extensive fund raising campaign, $252,962 was collected, and construction began on a then-modern 65-bed hospital. On July 9, 1929, the facility opened its doors, and the first patient was admitted. The first hospital director was Ira Dodge. The bottom photograph shows Marietta Memorial Hospital in relation to the Muskingum River. (MACC.)

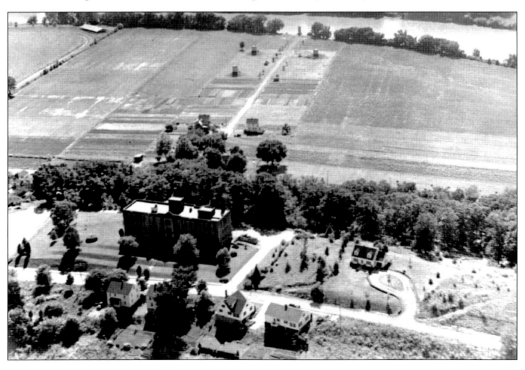

The Phoenix Mill Co. was originally located on the water's edge at the foot of Butler Street. Its waterpower was supplied by a millrace that flowed down Union Street to Goose Run. The offices and store rooms moved to the St. Clair building, No. 2, on Union Street, after the burning of their mill on the night of December 12, 1912. The Phoenix Mill Co. wholesaled winter and spring wheat flour and Kansas hard wheat flour. The mill also handled many other types of feed and grain. Their sales territory covered over 75 miles in each direction.

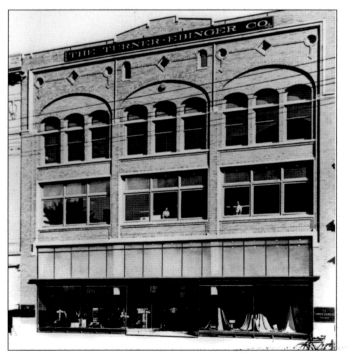

S.R. Turner founded the business now known as the Turner-Ebinger Co. in 1848. It was originally known as a general store and stood on Front Street where Al. Richard's Drug Store was located. In August 1911, Turner occupied the location shown here. In its day, residents considered the store a "Daylight Store" due to the large windows, which could swing open. The store employed over 60 people in 1916. The store was known to carry high-grade merchandise for the discerning customer.

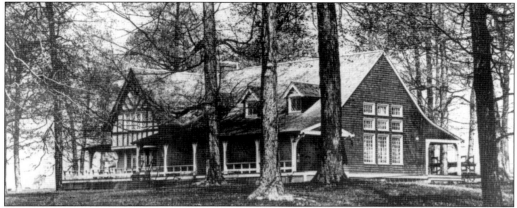

The Marietta County Club was organized in 1900 by a group of people who wanted to introduce and play the new game of golf in Marietta. The nine-hole course was located in the maple groves just north of Marietta in the area now known as Devola. Nearly 30 acres were leased from the Chamberlain and Devol families. The Alpine-English club house, with large verandas and a large dining room, was able to seat 150 people. Above the kitchen and dining room was a large apartment for the chef and family. In the early 1920s, the Marietta Country Club membership split down the middle, as one group desired an 18-hole course. The splinter group purchased 204 acres on Newport Pike next to Duck Creek and built the Washington Country Club. The Marietta Country Club house burned down on June 1, 1933, and the Washington Country Club went into bankruptcy in January 1934. These tragedies later reunited both factions.

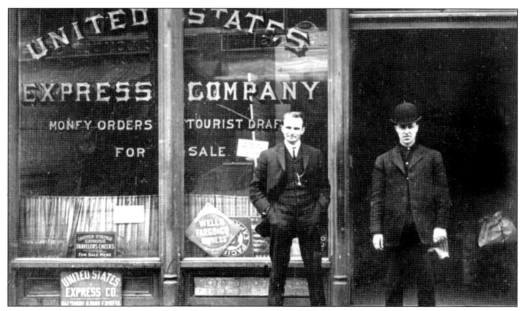

The United States Express Co. office was located at 195 Front Street opposite the St. Cloud Hotel in 1904. Shown standing left to right are 27-year-old Joe Goss, manager and express agent and Wayne Warren, deliveryman. In 1918, the United States Express Co. merged with seven other express companies and was called the American Railway Express Co. Express shipments arrived via railroad trains, and shipments were said to be more reliable than the U.S. Mail service.

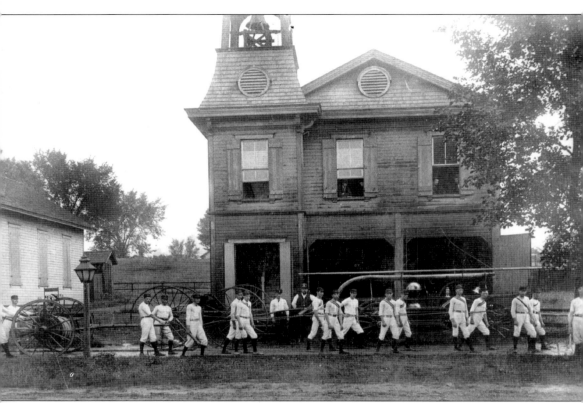

In the late 1800s, volunteer firefighters, democratic and proud, jealously protective of their organization, and conscious of their importance to the community, garnered colorful names for their companies. The company shown here was called Defiance No.1. It was an exclusive club, and membership was symbolic of dignity and high standing in the community. This photograph was taken in front of the Defiance Station Club House, located where Washington School now stands. This building was moved to Fourth Street, across from Marion School, and was converted into a two-family residence, complete with bell tower. This photograph is from *c.* 1889. Left to right in harness are: Lew Kexell, Chas. Campbell, Chas. Beck, John Lorentz, Wm. Boeshar, J. Congdar, Adam Weber, Boots Danker, Dan Biszantz, Wm. McClaren, Mart Lancaster, John Bernhart, Henry Beck, Dave Schlicher, Henry Otterbine, Fritz Abbicht, and Ed. Backus.

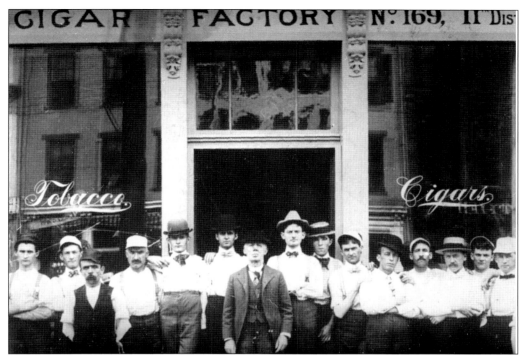

No town was complete until it had a cigar factory. Charles H. Hutchins was located on the ground floor of a building at 125 Front Street. The factory workers are sporting their finest hats. By 1910, Mr. Hutchins had passed on, and C. Pape became the proprietor and moved the business to 172 Front Street.

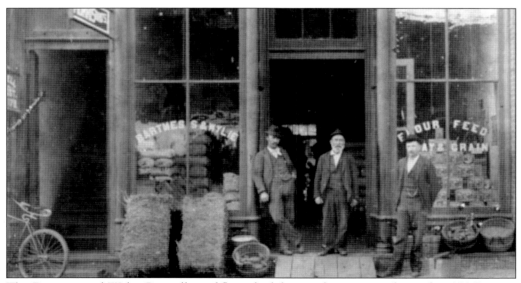

The Bartmess and Wylie Co., sellers of flour, feed, hay, and grain, were located at 121 Putnam Street in Marietta c. 1893. This building was later the location of B.S. Sprague Electric Co. and later yet, a part of J.C. Penny Co. Today this building has been incorporated into Putnam Street Commons—a conglomeration of eateries, offices, and shops.

The Young Men's Christian Association formed in Marietta in 1900. Marietta citizens completed the YMCA building in 1902 with donations. The old YMCA building is shown in a post card canceled on October 21, 1908. For over 50 years, the building served the men and boys of Marietta. In 1949, Thomas H. Cisler, a charter member of the "Y," donated a tract of land below his home for the new building, which was completed in 1954 and is now open to families.

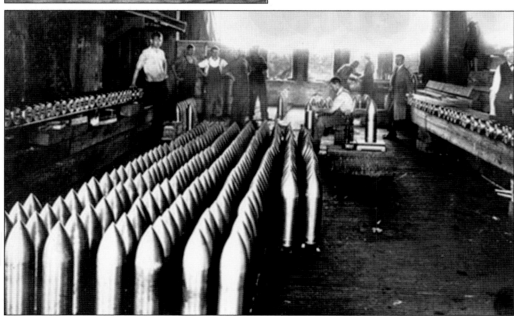

In 1915, the Leidecker Tool Company received its biggest contract ever. Foster H. Leidecker, president of the company, returned from Washington, D.C., with the news that they would hire 60 additional men and would keep the factory working around the clock for the next year. The factory manufactured high explosive projectile and shrapnel shells. Steel was shipped in from Richmond, Virginia, and one shell out of each completed lot was shipped to Washington, D.C., for testing on firing grounds.

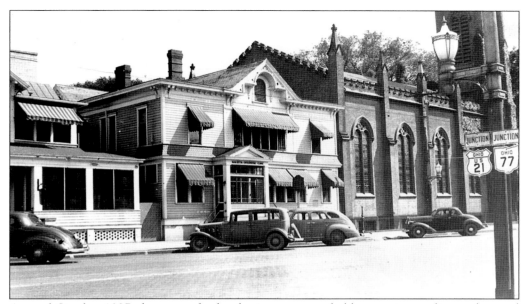

Around October 1927, doctors and other business persons held a meeting to discuss the need for a health clinic in Marietta. In 1929, the first physician intern arrived for training. On December 1, 1927, the doors of the Marietta Clinic were opened. By December 30, 1934, the Marietta Osteopathic Hospital was organized and formed. July 21, 1935, was the formal opening of the new hospital on Putnam Street, immediately behind the Universal Unitarian Church. On May 12, 1939, a major building expansion was completed. In 1958, the name was changed from Marietta Osteopathic Hospital to Selby General Hospital. In May 1965, Selby opened as an 80-bed full-service hospital at 1106 Colgate Street.

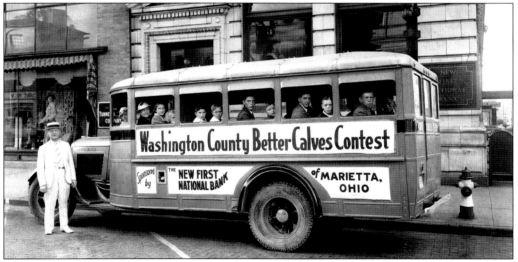

Originally established at the corner of Putnam and Second Streets in July 1899, the German Nation Bank was the originator and sponsor of many events and organizations in its day. These events included starting a Christmas Fund Drive in Marietta and sponsoring the yearly Washington County Fair Better Calves Contest. These Better Calves Contest winners are on their way to the state fair around 1940. The bus belonged to P. Westbrook and was driven by Nick Schramm.

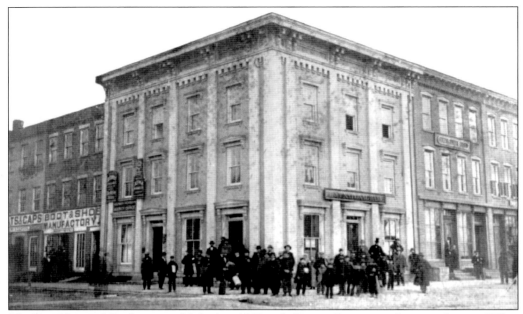

The First National Bank was established in 1863 with Beman Gates as its first president and Wm. Curtis as the first cashier. The First National Bank occupied temporary quarters in the Bellevue Hotel while its new home was being built and completed in 1865. A newer bank was built in 1902. The volume of business for the bank for 1916 exceeded $92 million. The First National Bank was considered the leading financial institution of southeastern Ohio. Officers in 1916 were Wm. W. Mills, president; G.C. Best, vice president; and J.S. Goebel, vice president and cashier.

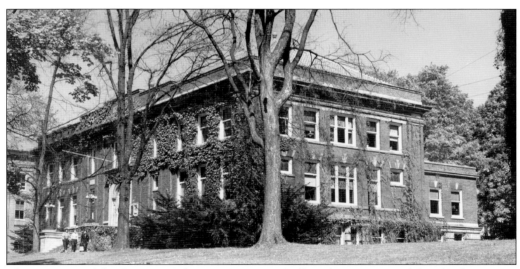

This is a view of the Carnegie Library at Marietta College from a postcard dated February 21, 1908. The library was the center of the Marietta College campus for many years. In 1907, Andrew Carnegie gave the College $40,000 towards building a new library as the old library was housed in Alumni Hall, built in 1871. In 1961, a new library was built on the other side of Fifth Street. The Carnegie-built library now serves as the Irvine Administration Building. (MACC.)

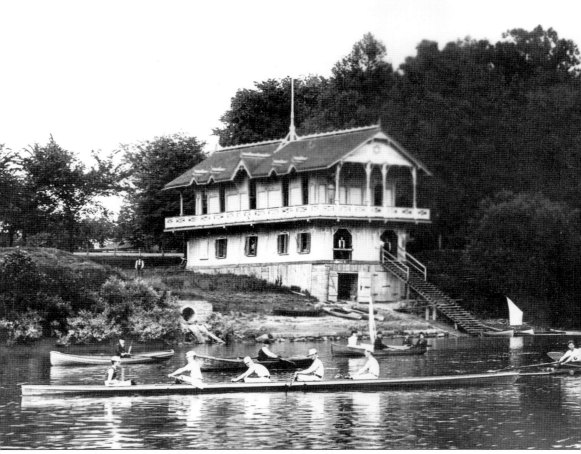

Few shots still exist of the old crew building on the Muskingum River. A crew team races past Mariettans out for summer leisure boating. This wooden building housed the Marietta College crew and was the clubhouse of the Lobdell Cycling Club. Notice the storm drain coming off of Front Street. This boathouse was across Front Street from the Elks club. The boathouse washed away in the March 29, 1913 flood.

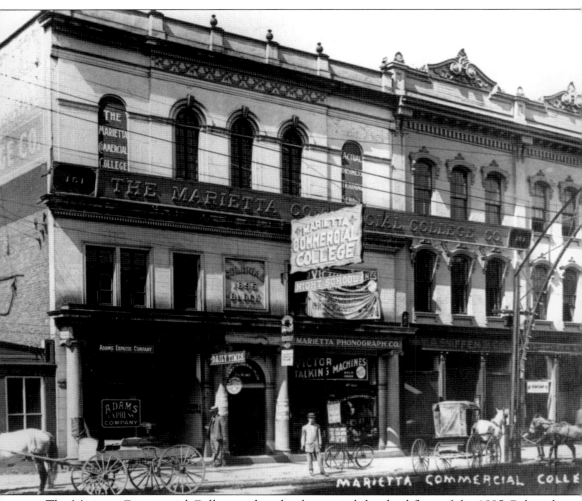

The Marietta Commercial College night school occupied the third floor of the 1895 Colonial Block in Marietta in the early 1900s. Housed beneath the college were the Adams Express Company, the *Marietta Daily Times*, and the Marietta Phonograph Company, featuring "Victor Talking Machines and the Edison Phonograph."

Marietta's Union Depot was located on Second Street just below Putnam Street. The United Terminal Railway Co. was chartered in 1890 with $200,000 capital. Built in 1890, fire in 1910 gutted the third floor, so it was made into a two-story structure. At one time, 21 daily scheduled trains arrived and departed from Union Station. The big train shed in the rear was removed in July 1932. In December 1944, work started in razing the red brick structure. F. Leonard Christy salvaged the red tile roofing and used it for his home in Devola.

The land the Union Depot was built on was considered swamp land and was raised 15–20 feet. Privileges and offices were leased by the B&O, the T.O.C. Extension Rail Road, and the Ohio and Little Kanawha Railroads. The Pennsylvania Railroad did not use the Union Depot and maintained its own passenger and freight facility on Second Street below Butler Street. The large and ornate Union Depot was nicknamed "Pillsbury's Grand Union Hotel," as it had upper floors equipped with a restaurant and sleeping room facilities.

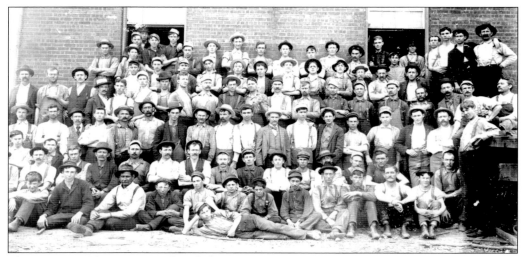

The Marietta Chair Co. was founded in 1856 at Putnam and Seventh Streets. Including the lumberyards, it occupied 11 acres of space. The plant's 300 plus employees received a 30¢-per-hour starting rate as late as 1941. The plant was known as the "Dutch College," as many of its workers were of German descent. Working at the factory was a family affair, with fathers, sons, uncles, and cousins on the work force together. Black smoke pouring from the brick smokestack at Putnam Street was good news to Marietta, as it meant one of the city's top employers was producing. Traffic jams were nil, as most men walked to work with their lunch pails. Some of the chairs are still used today, more than 55 years after the company went out of business.

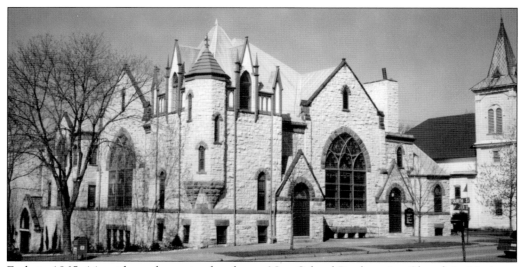

Early in 1865, 14 residents determined to form a New School Presbyterian Church in Marietta. Signing the resolution forming the First Presbyterian Church in Marietta were: Silas Slocomb, H.B. Shipman, M.F. Hay, E.B. Andrews, Sala Bosworth, George H. Ells, Sarah C. Dawes, Laura E. Currier, J.D. Cotton, Lucy Dawes, and J. M. Slocomb. A temporary church home was found in the old Lutheran Church at 4th and Scammel Streets, and the church was formally organized by the Reverend Ballantine, the Reverend E.B. Andrews of Marietta College, and the Reverend C.D. Curtis, with 53 charter members. On October 8, 1896, the cornerstone of the current First Presbyterian Church was laid, and the church was dedicated on June 6, 1897.

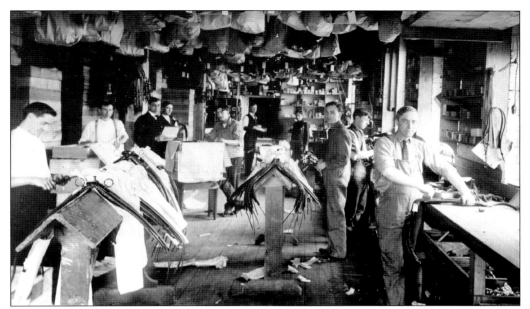

C.F. and B.F. Strecker started a leather business in 1881. They also bought hides, sheepskin, tallow, and furs. They began making horse collars, saddles, etc. in 1890. In 1916, they employed 200 men, and 25 salesmen made trips from the Great Lakes to the Gulf of Mexico. The dollar amount of harnesses sold in 1916 was over $1 million. The Strecker Brothers Co. was one of Marietta's largest industries and one of the largest saddlery manufacturers in the U.S.

Organized in 1898, the Marietta Paint and Color Co. was recognized as a leader of its product line within 19 years. The company was pre-eminent in the field of wood-finishing materials for furniture, piano, and talking machine manufacturers. Marietta Paint practiced a vigorous advertising policy in New England newspapers. The company was located in Norwood and was noticeably conspicuous for its flourishing flowers, shrubs, and trees, tended to by the company's landscape gardener. This photograph taken in 1937 is of W.F. Smith, E. Gibson, and M. Dyer.

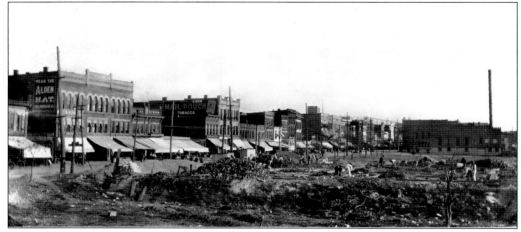

The Marietta Post Office has resided in 20 different locations in Marietta throughout its life. The first post office was at the Meigs and Greene Store in front of present Ohio and Muskingum Streets. Return J. Meigs Jr. was postmaster from 1794–1795. The second post office was at the southeast corner of Post and Munroe Streets, now the back of Mahone Tire. Josiah Munroe was postmaster from 1795–1801. The foundation for the final post office is shown being laid in 1909. Notice the Armory has not been built yet.

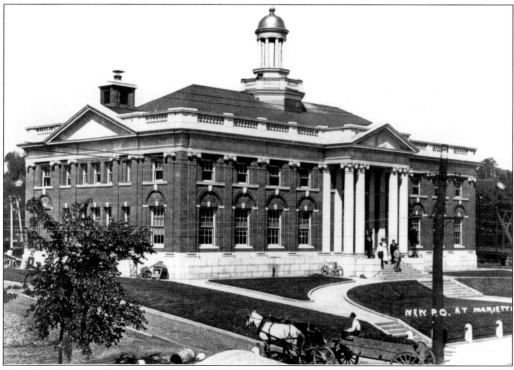

The first free-standing post office in Marietta was erected on the Ice Harbor lot 1909–1911, opening in 1912 with Gamaliel J. Lund as postmaster. This was the twentieth location of the Marietta post office. Immediately prior to this location, the post office was housed in the St. Clair building on Putnam Street, with Alva M. Rose as postmaster.

In December 1909, the Marietta City Council approved a resolution offering land to the State Armory Board at no charge. After much delay, the Marietta Armory was built in 1915. The Armory was the center of patriotic activity during the First and Second World Wars. In 1918, it filled with women making socks, scarves, and gloves for soldiers. Blankets and supplies were also issued from the Armory during emergencies. The Armory was designed as a fortification in case of riots or civil war. The building's cost was $27,944. The narrow windows could serve as gun turrets. For many years, city industrial league games were played in the facility. The area behind the building was used for service vehicles, and the building included a firing range, mess hall, and meeting rooms. The Ohio National Guard moved out in 1992, and the City of Marietta purchased the property back from the state in 1997. The future of the Armory building remained undecided in 2003.

The lock house number 1, built in 1898 in downtown Marietta cost $3,500. The house was home to the lockmaster and his family. The lockmaster position was held through the Civil Service, and only qualified former steamboat men were considered. The lockmaster was responsible for locking boats from one pool to the other 24 hours per day. Each lock had an approximate ten-foot drop, and it took about nine minutes for a river steamboat to clear the lock. The lockmasters knew most of the river skippers by first name, as repeat river traffic was heavy during the riverboat's heyday.

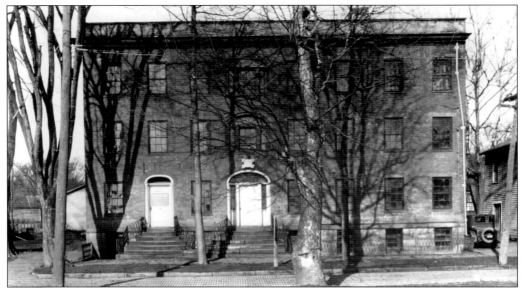

This imposing building was the first hotel built in the upper Ohio River Valley. It was called the Exchange Hotel and was constructed in 1831. The building had 36,000 square feet and was convenient to rail and boat transportation. The Stevens Organ Co. moved into this building on lower Gillman Avenue in West Marietta (formerly Harmar) in 1892. Mr. Stevens passed away on April 30, 1921, and was buried in Oak Grove Cemetery. By 1922, the Steven's Organ Co. only manufactured Alethetone Talking Machines, one of Mr. Steven's inventions. By 1924, the Steven's Organ Co. was listed in the city directory only as a phonograph manufacturer. The company closed in 1924.

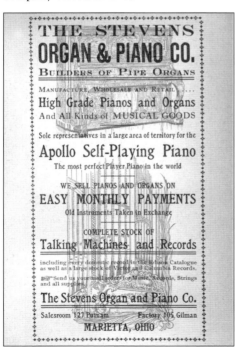

Mr. Collin R. Stevens arrived in Marietta in 1888. He was from Brattleboro, Vermont, and had been employed by the Estey Organ Co. When he arrived in Marietta, he opened a retail piano and music store on Front Street, later moving his establishment to Putnam Street. In 1892, he organized the Stevens Organ and Piano Co., which was engaged in the manufacture of organs and pianos. Mr. Stevens sold his retail store and stock to Wainwright Music Co. in 1911 for $25,000.

54

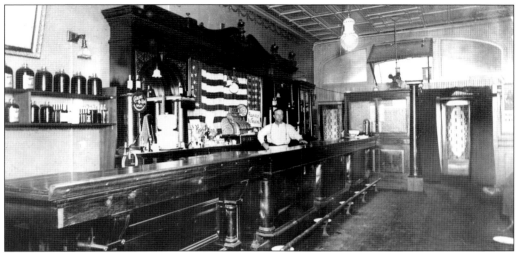

In 1895, Marietta had no less than 32 saloons or "sample rooms," as they were known. The Vestibule saloon of Arthur Wing Devol (1861–1961) opened in 1895 at 123 Putnam Street. In 1898, it moved to 118 Front Street. George Parker, Arthur's brother-in-law, was the bartender. By 1900, the sample room had been sold to P.J. Donnelly. On Saturday January 16, 1909 at 11 p.m., the legal sale of liquor ended in Marietta and Washington County due to the Rose Law. The Vestibule saloon never opened its doors again.

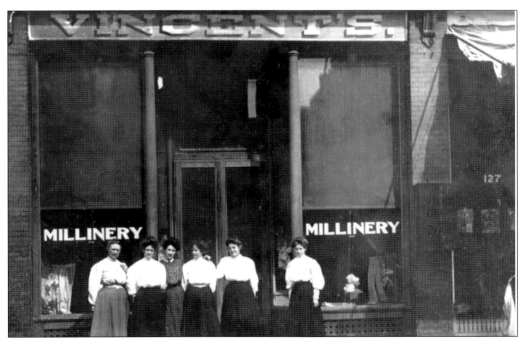

Vincent's Millinery first appeared on the Marietta horizon in 1902. They were first located at Third and Marion Streets with H.C. Vincent, a druggist. By 1910, Vincent's had moved to 125 Putnam Street, and the business was listed under both Fred W. and Flora D. Vincent, milliner and druggist. By 1912, the Vincent's had moved from Marietta. Only eight milliners were located in the city directory of 1912.

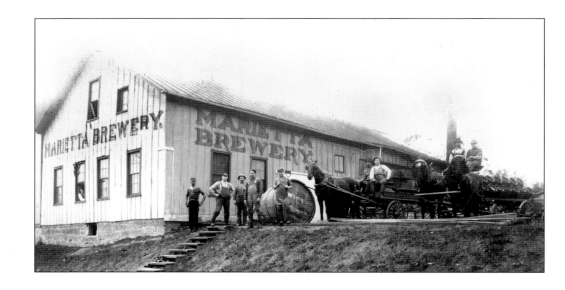

The Marietta Brewery was one of several operating in Marietta in the early years of the twentieth century. Originally known as the Union Brewery from 1860 until 1890, it closed and then reopened in 1898 as the Marietta Brewery. It maintained that name until 1903 when it was renamed the Marietta Brewing Co. At one time, Marietta had as many as three breweries and five bottling companies. Remnants of the old brewery still exist behind the medical offices on Second Street.

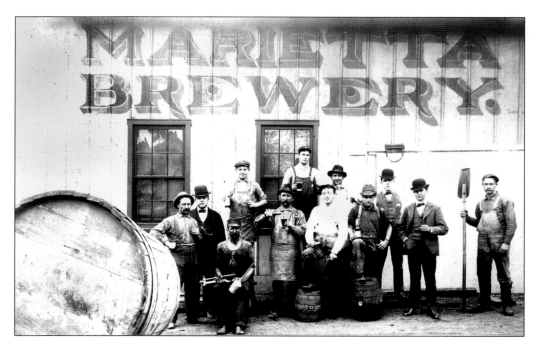

On February 3, 1900, the second Marietta High School building was constructed on Scammel Street between Fourth and Fifth, on the same site as the original school building. The second school was dedicated on Friday, October 11, 1901. Soon, the building became too crowded and a third high school, pictured here, was built in 1925–1927 on High School/Cisler Hill. The doors opened in 1928 and the principal was A. R. Keppel. A fourth high school was constructed in 1964–1966 on Davis Avenue and this building was converted into Marietta Middle School.

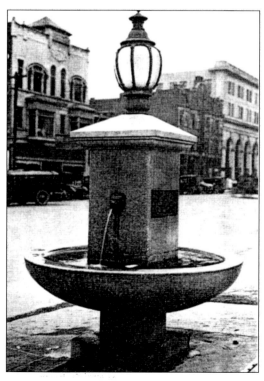

This fountain was given to the city of Marietta in 1924 by Sarah R. Warren. Miss Warren was a great lover of horses, dogs, and birds and had this fountain placed for them. Jacob H. Staker was the designer and builder. Valley Monument Works in McConnelsville, Ohio, provided the concrete and placement. The fountain has been moved several times, including to the Harmar end of Putnam Street Bridge, B&O railroad yard, Civitan Park, and the Second Street end of Camp Tupper. Along with Marietta's three other fountains and horse troughs, it now serves as a decorative flower container. Inscribed on one side of the fountain is Sarah Warren's favorite quote from Samuel Taylor Coleridge's *The Rime of the Ancient Mariner*:

> "He prayeth best, who loveth best
> All things both great and small;
> For the dear God who loveth us,
> He made and loveth all."

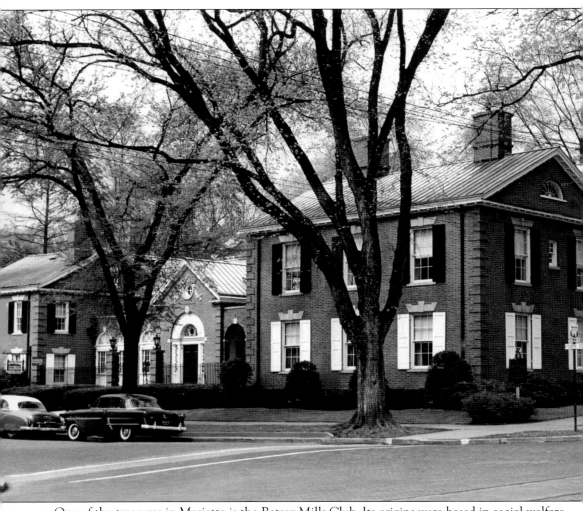

One of the treasures in Marietta is the Betsey Mills Club. Its origins were based in social welfare work Betsey Gates Mills accomplished with young women in the early 1900s. With a donation for the building from William W. Mills as a memorial to his wife, two houses, including Betsey Mills' childhood home (where Vice President Charles G. Dawes was born) were joined together with additions to form the club complex in 1927. The second and third floors are women's dormitories. Part of the first floor houses a dining room open to the public. Other parts of the building house a daycare center, warm water swimming pool, and gymnasium. The Betsey Mills Club is locally administered and locally funded. (MACC.)

# *Four*

# ROLLING DOWN THE RIVER

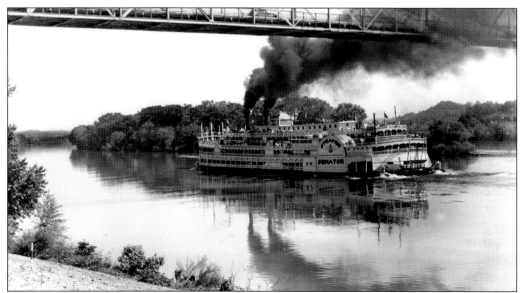

The steamer *Senator* passes under the Williamstown Bridge near Buckley's Island on her journey north, *c.* 1942. The *Senator*, a side-wheel excursion boat built in Dubuque, Iowa, in 1903, was originally the *Saint Paul*. She was rebuilt at Paducah, Kentucky, 1939–1940, and renamed *Senator*. Streckfus Steamers, Inc. of St. Louis owned her. She operated on the Ohio River based at Pittsburgh for the seasons of 1940 and 1941. Masters were Captains Edgar F. Mabrey, Clarence W. Elder, and T. Kent Booth. Due to World War II, she was retired in 1942 to serve in St. Louis as a U.S. Coast Guard training ship. From 1943 on, Streckfus used her as a floating machine shop and warehouse. On January 19, 1953, the tug, *Susie Hazard* towed her below St. Louis for abandonment.

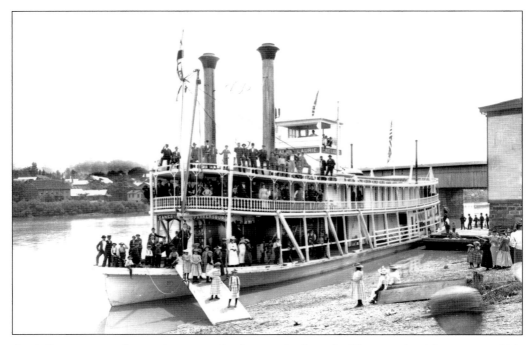

*Annie Laurie*, a wooden packet sternwheeler, was built at the Knox yard at Marietta in 1892. The original crew ran the Zanesville to Parkersburg trade. The captain was George Wallace. In 1899, the *Annie Laurie* was sold to the Vicksburg and Greenville Packet Co. and ran that trade successfully. In 1903, it beached above Glass Bayou in Lake Centennial at Vicksburg. The cabin and engines were removed, and the hull became a barge. In the photograph below, the men and boys are out on a trip aboard the *Annie Laurie* steamer, *c.* 1900. Notice the spittoons. (WCHS.)

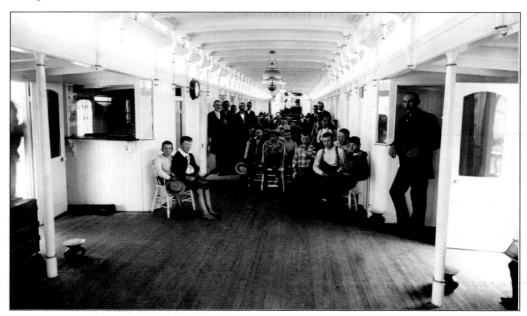

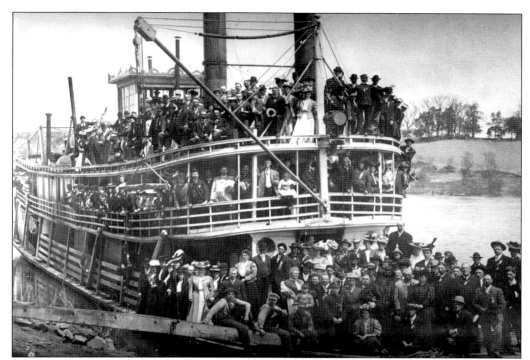

On Thursday, May 16, 1907, over 250 members of The 55th Council of Improved Order of Red Men and their ladies went on an excursion down to Blennerhasset Island. The boat they chartered was the *Sonoma*. The captain of the vessel, E.W. Webster, was an ardent member of the Odd Fellows Lodge.

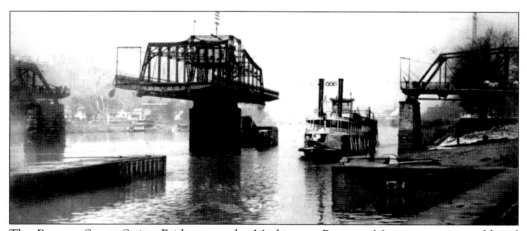

The Putnam Street Swing Bridge over the Muskingum River at Marietta appears cold and foreboding in this winter photograph. The boat, once again, is the *Sonoma, c.* 1904. The *Sonoma* ran daily except Sunday between Marietta and Beverly. It took the boat approximately five hours to travel 25.1 miles. Notice the white horse-drawn wagons waiting to cross the bridge in the upper right hand corner of the photograph.

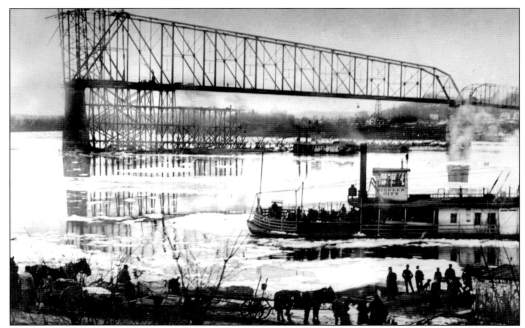

The *Pioneer City* and the *Williamstown Ferry* pass near the Ohio River Bridge construction in 1902. The *Pioneer City* replaced the *Emmu UHL* in ferry service between Marietta and Williamstown. She was owned by Beman Dawes when the highway bridge was completed in 1903. She was sold in November 1905 to Martin H. Noll and leased to tow railroad-transfer barges at Parkersburg in the Little Kanawha River. She was again sold in 1907 and renamed the *Central City*.

The regularly scheduled Beverly-Marietta steamboat *Sonoma* locks through at Devols Dam on the Muskingum River, c. 1897. The *Sonoma* was built in 1881 at Harmar Shipyard. It was built for Captain Edmund B. Cooper, who ran the Parkersburg-Belleville trade on the Ohio River. She sank at Laurence's landing between Beverly and Luke Chute on April 19, 1910. The *Lorena* took her freight, and the towboat *Darling* pumped her out. After repair, she continued excursions on the Madison-Frankfort trade. Eventually, she turned over and sank after hitting a snag near Glen Mary on the Kentucky River. In this photograph, Captain Ed W. Webster is the pilot, and Isaac Lake Devol is the clerk. Union Mills is shown at right.

The Muskingum River is navigable within a series of locks from Marietta to Dresden a total of 93.1 miles. The lock and dam system was built in 1840 to make the river a commercial waterway. Once operated by the U.S. Corps of Engineers, the State of Ohio now maintains the river for recreation. Lock 1, which was at Marietta, was removed in 1968 after the Ohio River pool level was raised by the modern dam system.

# MUSKINGUM RIVER LOCK AND DAM SYSTEM

**The Lock and Dam System was built in 1840 to turn the river into a commercial waterway. It runs 93 miles from Dresden, Ohio to Marietta, Ohio. Once maintained by the U. S. Corp of Engineers, the State of Ohio assumed operation on November 20, 1958.**

|  | Miles from Ohio River |
|---|---|
| Lock 1 - Marietta. Removed in 1968. |  |
| Lock 2 - Devola | 5.8 |
| Lock 3 - Lowell | 14.2 |
| Lock 4 - Beverly | 25.1 |
| Lock 5 - Luke Chute | 34.1 |
| Lock 6 - Stockport | 40.2 |
| Lock 7 - McConnelsville | 49.4 |
| Lock 8 - Rokeby | 57.4 |
| Lock 9 - Philo | 68.3 |
| Lock 10 - Zanesville | 77.4 |
| Lock 11 - Ellis | 85.9 |

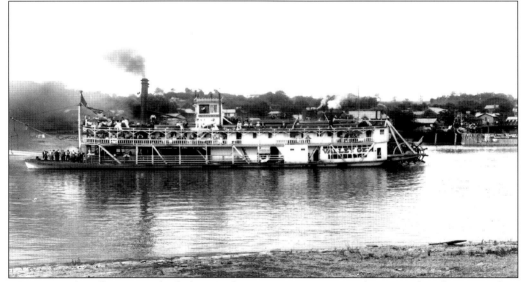

The original *Valley Gem* plied the Muskingum River, just as the second *Valley Gem* does today. The first *Valley Gem* was built at the Knox boat yard in 1897. It was built for the McConnelsville-Zanesville, Ohio, trade on the Muskingum River. Captain Newton Price was the master and a part owner. He ran this trade from 1898–1917. The *Valley Gem* carried a crew of 18–25 men and was allowed 300 passengers and 156 tons of freight. On pleasure excursions, the *Valley Gem* carried an orchestra, and the passengers danced on deck. The *Valley Gem* was destroyed by ice on February 1, 1918, near Morgantown, West Virginia.

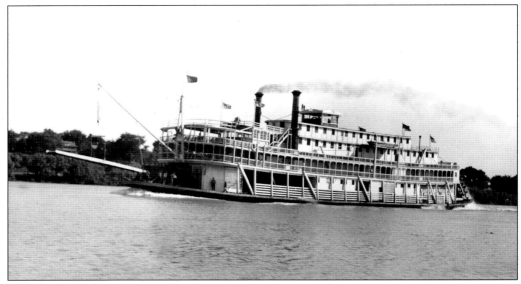

The *Gordon C. Greene* was originally named the *Cape Girardeau*. She was built in Jeffersonville, Indiana, by the Howard boat yards in 1923. The Greene Line Steamers in Cincinnati acquired her from Eagle Packet Co. of St. Louis and changed her name and she then ran the Pittsburgh-Cincinnati line. She was a coal burner until fitted with oil burners in 1941. She became the family boat of Captain Tom R. Greene and was used as a floating convention center. Upon the building of the *Delta Queen*, the *Gordon C. Greene* moved to the St. Louis-Saint Paul trade. On Sunday, December 3, 1967, she sank under the Eads Bridge in St. Louis.

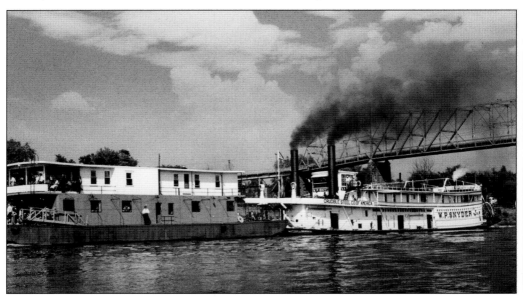

The *W.P. Snyder Jr.* arrives in Marietta, June 1955, as a gift of the Crucible Steel Co. of America, to the Ohio Historical Society. The *Snyder* is pushing a party barge owned by the U.S. Steel Co., loaned for the occasion. The *Snyder* came from Pittsburgh under its own power. Its captain was Frederick Way Jr., a long-time riverboat pilot, reporter, book writer, and president of the Sons and Daughters of the Pioneer Rivermen from 1941 until his death in 1992.

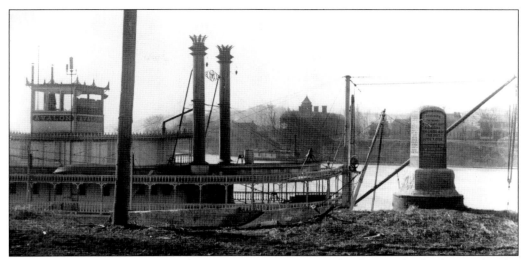

This photograph shows the *Avalon* at Marietta. Harmar School is in the background. Also shown is the Pioneer Monument, in its original location by the Muskingum River. This monument was erected by the New Century Historical Society in honor of the 48 pioneers who first landed near the same spot. The *Avalon*, built and operated by the Cramer family of Clarington, Ohio, was headed by Captain Lanford Cramer. The *Avalon* plied the Pittsburgh-Parkersburg trade in early August 1898 and ran through 1900. In 1901, she was taken to the Tennessee River for trade out of Chattanooga. She was returned to the docks at Parkersburg, West Virginia, and lengthened 35 feet that same summer. She sank at Scull Run on the Ohio River on November 30, 1906, and was raised a week later. She burned at the mouth of the Little Kanawha River on February 2, 1916. (WCHS.)

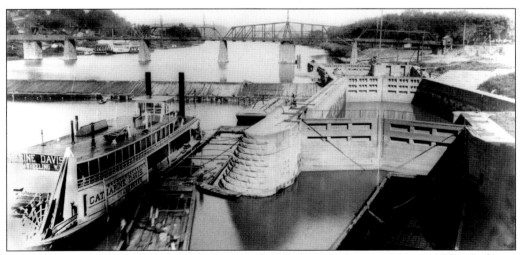

The *Catherine Davis* rests beside Lock No.1 on the Muskingum River at Marietta. The *Catherine Davis* was a sternwheel towboat with a steel hull. She plied the rivers from 1928–1949. She was built in Jeffersonville, Indiana, by the Howard Ship Yard, using machinery from an old boat of the same name. The *Catherine Davis* was owned by the Island Creek Coal Co. of Huntington, West Virginia. Captain J. Emory Edgington was master in 1935, with Raymond Young and Russell Riley as pilots. Ray Gill and Alex McGee were the engineers. Captain Ned Hamilton was commanding her when she was laid up in 1949. She was dismantled in Huntington, West Virginia. (WCHS.)

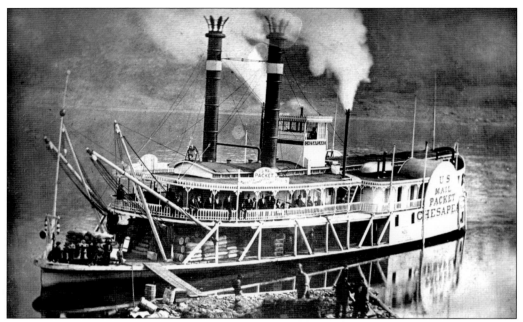

The *Chesapeake* mail packet, built at Irontown, Ohio, in 1871 by the M. Wise and Co. yard, began work on the Portsmouth-Guyandotte trade. In April 1873, she was sold to the Parkersburg and Ohio River Transport Co. In the fall of 1876, she was stranded high and dry at Sand Creek below Ravenswood—right alongside the stranded towboat, *Enterprise*. In April 1880, she was moved to Pittsburgh to run excursions. In April 1887, some boys started a wagon rolling down the wharf at the foot of Market Street in Pittsburgh, and the wagon's tongue stabbed the *Chesapeake*'s hull, sinking her. (WCHS.)

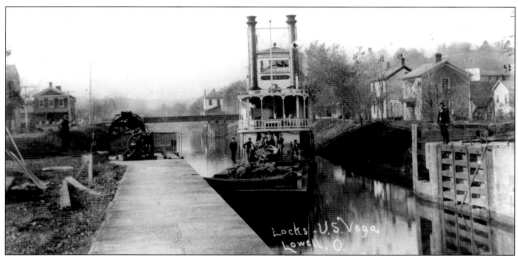

Slowly easing her way through the lock at Lowell, Ohio, is the United States Government Repair Boat *Vega*. This *Vega* replaced the original *Vega* whose boiler had exploded two years previously. The average lifespan for packet boats in the early 1900s was only five years due to crude design and construction and lack of safety standards. The *Vega* worked the Muskingum River towing dredge boats until sold to Pittsburgh interests in 1918.

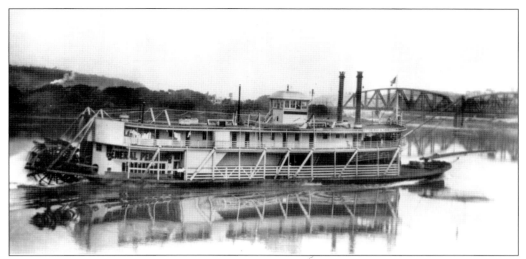

The *Lora* was built in Stillwater, Minnesota, in 1900 from machinery from the rafter *Flora Clark*. She ran briefly on the upper Mississippi. The Liberty Transit Co. in Wheeling, West Virginia, purchased her in 1918, remodeled her at Clarington, Ohio, and renamed her the *General Pershing* for Ohio trade. Captain W.L. Guthrie was the master; F. Way Jr., the clerk; and Dan Pathcel and Edward Sims, the pilots. She was laid up at South Docks, Point Pleasant, West Virginia, in November 1921. She never operated again. (WCHS.)

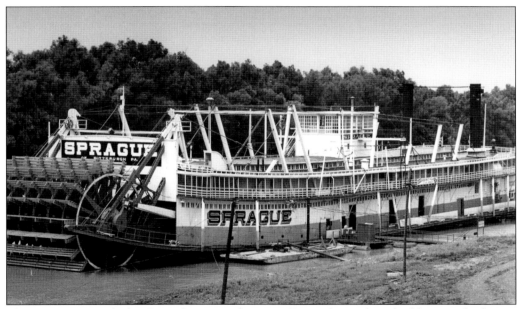

The *Sprague*, named after Peter Sprague, a longtime Pennsylvania boat builder, was the largest towboat ever built for the inland river system. She was launched on December 5, 1901, and was 318 feet long and cost $192,000. She held 30–40 days of cold supplies for the crew and had a large kitchen, bakery, and laundry. Each crew member had their own cabin. She established a record in 1907 by towing 60 barges that covered 6.5 acres containing 67,307 tons of coal—enough to fill 1,500 railroad hopper cars. The *Sprague* was retired to become a tourist attraction at Vicksburg in 1948. She burned on May 15, 1974.

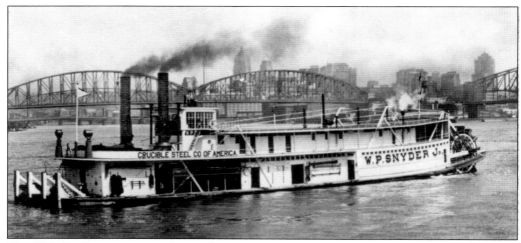

The *W.P. Snyder* cruises near the confluence of the Monongahela, Allegheny, and Ohio Rivers at Pittsburgh during it working days. The *W.P. Snyder* was born the *W.H. Clingerman* in 1918. Built by the firm of James Reese and Sons Co., she was used primarily to bring coal from the mines along the upper Monongahela River to the Carnegie works downriver at Clairton. In 1938, she was renamed the *J.L. Perry*, and in 1945, she was renamed the *A-1* by the military. In the fall of 1945, the Crucible Steel Co. bought her and renamed her the *W.P. Snyder Jr.* She continued to tow coal for nine years until retired in 1954.

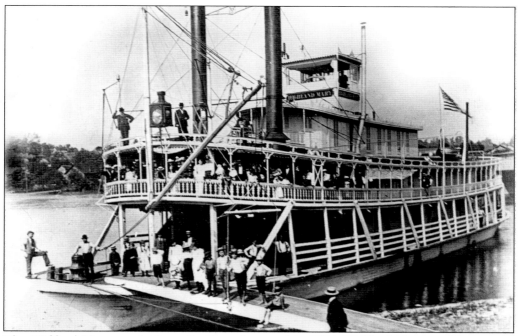

The *Highland Mary* was built at the Knox boatyard in 1894. *Highland Mary* used compound condensing engines designed by Griffith and Wedge of Zanesville, Ohio. She was owned by Captain Wm.W. Richardson, George Wallace, Dana Scott, Lou Myrick, John Rice, and Charles S. Beckwith. Designed for the Pittsburgh-Zanesville trade, she was sold in September 1894 to the Magdalena River Corp. in South America.

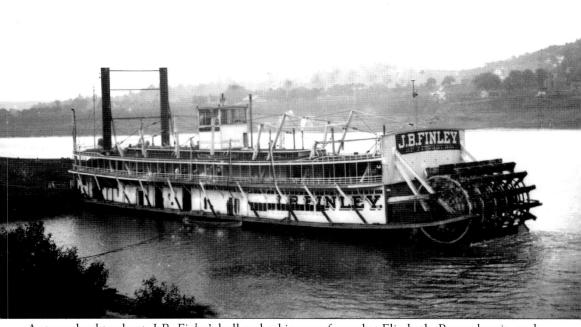

A sternwheel towboat, *J.B. Finley*'s hull and cabin were formed at Elizabeth, Pennsylvania, and completed at Marietta in 1899. Her condensing engines were manufactured by the Marietta Manufacturing Co. She was originally named the *Transporter*, but was renamed the *J.B. Finley* after J.B. Finley, Esquire and president of the Combine coal-shipping company, purchased her. The *J.B. Finley* set many towing records, including taking a tow of 24 loaded coalboats and four loaded barges over the falls at Louisville, saving 23 hours locking time. The *J.B. Finley* also had many big spills, losing 22 loads of coal and three loaded barges in one smash on the lower Ohio after breaking a rocker arm. In spring of 1903, she had an epidemic of smallpox on board, and she was laid up at Louisville and fumigated. In August 1918, the *J.B.Finley* was getting repairs at the Paducah Marine Ways when she burned. Frederick Way, author of *Way's Packet Directory*, reminisced about his first sighting of the *J.B. Finley*, when he was a teenager, "All in all, she was some great pumpkins, and I had enough sense to change my course upriver and stand goggle eyed watching her."

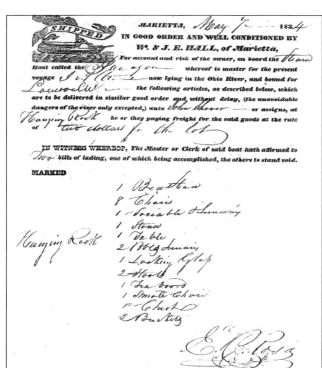

This shows the "Bill of Lading for John Shiver's Goods." Delivery was guaranteed by W. and J.E. Hall Co. Delivery was guaranteed except for "unavoidable dangers of the river." The boat was scheduled for departure on May 7, 1834. Items were to be delivered to Lawrenceville from Marietta for the sum of $2. Items shipped included eight chairs, one stove, one table, one looking glass, two hooks, one small chair, two tray boards, one chicken, and two buckets.

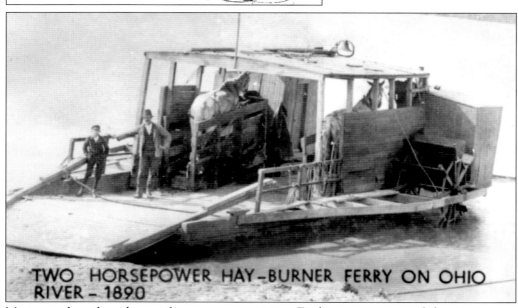

## TWO HORSEPOWER HAY–BURNER FERRY ON OHIO RIVER – 1890

Mariettans have been known for great improvisation. Finding means to travel the river was no exception. This unidentified man and youngster take advantage of the original horse power. They didn't need to worry about running out of steam or boiler explosions—a bail of hay could keep them running for a week. The ferry didn't use conveyor belts—the horses walked on revolving steps. One question comes to mind. . . . If one horse was plodding faster than the other, would the boat go in circles instead of straight?

*Five*

# BY PLANE OR
# BY TRAIN

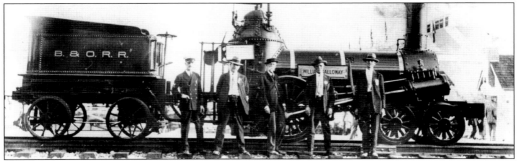

The Belpre Cincinnati Railroad Co. was chartered in March of 1845. The bill was introduced in the Ohio House of Representatives by 33-year-old William Parker Cutler, son of Ephraim Cutler (writer of the first tax laws of Ohio) and grandson of Manasseh Cutler (an architect of the Northwest Ordinance and a colleague of George Washington in the Ohio Company of Associates venture). Cutler enjoyed a close rapport with Thomas Swann, president of the Baltimore and Ohio Railroad. Shown here is an early B&O locomotive, the *William Galloway*. The gentlemen in the picture are unidentified.

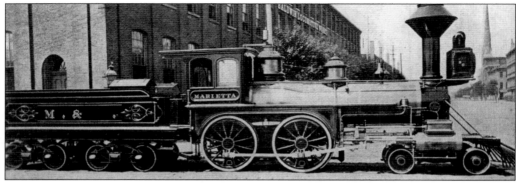

In the meantime, influential men in Marietta did not want the railroad to come to Parkersburg, so they formed the Franklin and Ohio River Railroad—on paper. This was merged with the Belpre and Cincinnati, and the name was changed to the Marietta and Cincinnati Railroad. The M&C reached Harmar (West Marietta) on April 9, 1857. In 1858, Cutler formed the Union Railroad, running from Moore's Junction to Belpre. Cutler sold it to the M&C for $125,000 even though it only cost him $50 to build. Shown here c. 1874 receiving its final preparations at the Baldwin Locomotive yards is the *Marietta*.

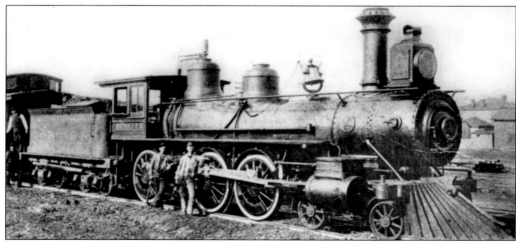

The M&C also began grading road bed north of Marietta to Wheeling, but iron was never laid on this leg of the road since the B&O soon bought its way into Parkersburg. It was the expense of this north leg that brought on bankruptcy of the M&C in 1858. Between 1859 and 1882, the B&O paid off liabilities to keep the M&C running. In 1883, the B&O finally bought the M&C. Pictured here on June 16, 1884, is one of the 24-passenger locomotives that the B&O acquired from the M&C.

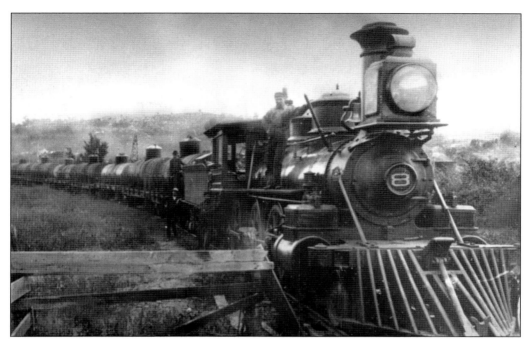

On the other side of Marietta ran the Marietta and Pittsburgh Railroad. This railroad was bought by the Pennsylvania Railroad and renamed the Cleveland and Marietta in 1890. Pictured is the Number 8 Rome 4-4-0 built in Rome, New York. The locomotive and crew pose at the edge of the Macksburg oil fields *circa* 1885. This locomotive later pulled passenger trains for the Marietta, Columbus, and Cleveland Railroad.

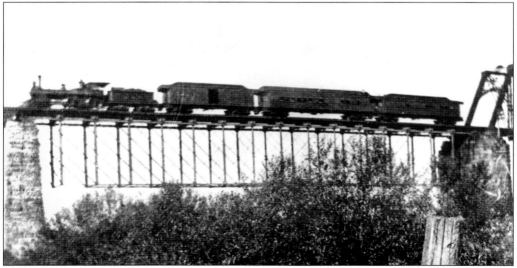

The B&O Muskingum River Bridge was originally built by the Marietta and Cincinnati Railroad. It was started in 1857, completed in 1859, and was a wooden covered bridge. On February 9, 1884, the fairgrounds barn floated down the flooding Muskingum River and took out both the Putnam Street bridge and the railroad bridge. Here, a train crosses the B&O trestle over the Muskingum River *c.* 1898.

## ZANESVILLE & OHIO RIVER RAILWAY.

**FORM L.**

ent's Stub. Lomax Improved

Combination Ticket.

**NOT GOOD FOR PASSAGE.**

**WATERFORD, O.**

to Station opposite Notch in margin.

189 Expires ed 189 Rate, $

| | |
|---|---|
| 0 | Zanesville. |
| 1 | Putnam. |
| 2 | Fair Oaks. |
| 4 | Buckeye. |
| 5 | Fraziers. |
| 6 | Sealover. |
| 10 | Philo. |
| 14 | Merriam. |
| 15 | Stone. |
| 16 | Cedar Run. |
| 18 | Durant. |
| 19 | Eagleport. |
| 23 | Shawnee Jct. |
| 25 | Children's H. |
| 26 | Malta. |
| 28 | Douda. |
| 31 | Sherwoodsb'g |
| 33 | Hooksburg. |
| 36 | Stockport. |
| 39 | Roxbury. |
| 40 | Brokaw. |
| 42 | Luke Chute. |
| 43 | Swift. |
| 45 | Beckett. |
| 46 | Relief. |
| 48 | Hayward. |
| 51 | Waterford. |
| 56 | Equity. |
| 58 | Clifton. |
| 61 | Lowell. |
| 64 | Rainbow. |
| 66 | Willow Farm. |
| 67 | Alden. |
| 69 | Devol. |
| 70 | Bartlett. |

The Zanesville and Ohio River Railroad ran from Zanesville to Marietta in the late 1800s. In 1900, the Z&OR went into receivership, and the Ohio and Little Kanawha Railroad became the successor. In 1902, the B&O Railroad bought the O&LK. Clergy rode for free if they provided their rail permit number. This ticket is from Waterford to Malta, a small hamlet north of Stockport.

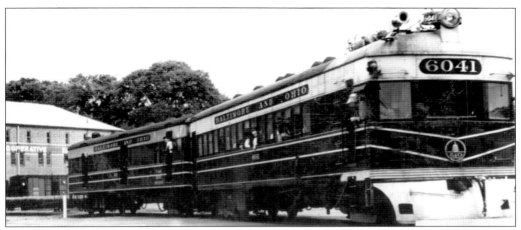

The B&O Railroad contracted with the J.G. Brill Co. of Philadelphia to produce all of its rail motorcars on Class 1 railroads in the U.S. The trains were Brill 800s and were affectionately known as "Doodlebugs." They worked well for commuter service and on short branch lines throughout Maryland, Pennsylvania, West Virginia, and Ohio. Here, the 6041 heads out on another run between Parkersburg, Marietta, and Zanesville.

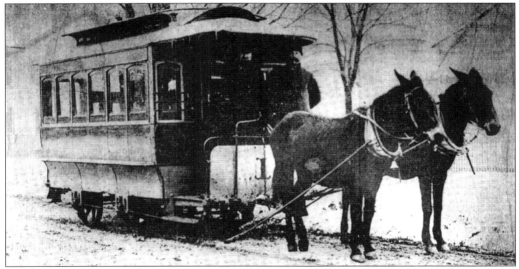

Street cars began operation in Marietta in 1890 with the Marietta Street Railway—all two miles of it. The cars were pulled by mules. The barns were located at the end of Third Street and Ferguson Street. The street cars ran down to Montgomery Street, onto Fourth Street, to Putnam Street, and then to Front Street. Here, the mules were unhitched and taken to the other end of the car and driven back over the line in reverse order. The company started operation with three bob-tailed cars. By 1898, a power plant was built on Second Street across from the Courthouse in order to run electrified cars.

## WESTWARD

| Distance from Parkersburg | Train Order Stations | O. & L. K. SUB-DIVISION TIME TABLE No. 56 September 30, 1951 | Passing Siding Capacity of Cars including engine and caboose | FIRST CLASS 955 DAILY Except Sunday | THIRD CLASS 381 DAILY Except Sunday | 373 Tues. Thur. Sat. only | 379 DAILY Except Sunday |
|---|---|---|---|---|---|---|---|
| | | | | P.M. | | A.M. | A.M. |
| 0.6 | DN | PARKERSBURG | | S 4.30 | | 7.45 | 8.30 |
| 1.3 | DN | BELPRE | | S 4.35 | | 7.55 | 8.40 |
| 5.1 | | BRIGGS | | F 4.41 | | | |
| 6.4 | | CONSTITUTION | 11 | F 4.44 | | 8.15 | 8.55 |
| 8.1 | | RIVERVIEW | | F 4.48 | | 8.20 | 9.00 |
| 9.4 | | BAKELITE | 63 | F 4.51 | | 8.24 | 9.05 |
| 10.4 | | MOORE'S JCT. | | F 4.53 | | 8.28 | 9.09 |
| 13.2 | D | WEST MARIETTA | 25 | S 4.58 | | 8.37 | 9.19 |
| 13.9 | | MARIETTA | | S 5.12 | | | A 9.30 |
| 13.2 | D | WEST MARIETTA | 25 | S 5.17 | | | |
| 13.9 | | HARMER | 23 | S 5.19 | | 8.47 | |
| 22.8 | | RAINBOW | | S 5.38 | | 9.13 | |
| 26.1 | | LOWELL | 20 | S 5.45 | | 9.25 | |
| 30.9 | | EQUITY | | F 5.54 | | 9.39 | |
| 33.8 | | CONGRESS RUN PIT | | 5.59 | | 9.53 | |
| 35.6 | D | WATERFORD | 11 | S 6.03 | | 10.07 | |
| 40.5 | | RELIEF | | F 6.12 | | 10.22 | |
| 41.5 | | BECKETT | 9 | F 6.15 | | 10.35 | |
| 43.7 | | SWIFT | | F 6.20 | | 10.42 | |
| 47.7 | | ROXBURY | | S 6.30 | | 10.52 | |
| 51.6 | | STOCKPORT | 20 | S 6.37 | | 11.02 | |
| 53.9 | | HOOKSBURG | | F 6.43 | | 11.12 | |
| 60.5 | D | MALTA | | S 7.00 | | 11.42 | |
| 60.8 | | McCOY SIDING | 17 | F 7.02 | | 11.47 | |
| 65.8 | | OIL SPRINGS | | F 7.08 | | 12.02 | |
| 67.9 | | EAGLEPORT | 5 | F 7.17 | | 12.30 | |
| 69.1 | | DURANT | | F 7.20 | | 12.39 | |
| 71.8 | | STONE | | F 7.25 | | 12.49 | |
| 73.5 | | MERRIAM | 6 | S 7.30 | | 12.59 | |
| 75.4 | | HOMER | | 7.34 | 6.30 | 1.05 | |
| 77.8 | D | PHILO | 35 | S 7.40 | 6.40 | 1.12 | |
| 80.0 | | SEALOVER | | 7.45 | 7.00 | 1.19 | |
| 82.9 | | N.Y.C. JUNCTION | | 7.50 | 7.10 | 1.29 | |
| 84.7 | | FAIR OAKS | 18 | S 7.56 | 7.20 | 1.38 | |
| 85.2 | | P.R.R. JUNCTION | | 8.01 | 7.30 | 1.49 | |
| | D | ZANESVILLE | | A 8.10 | A 7.40 | 1.59 | |
| | | | | P.M. | A.M. | P.M. | A.M. |
| | | Time over Sub-Division | | 3.26 | 1.00 | 5.54 | 0.50 |
| | | Average speed per hour | | 24.4 | 9.08 | 14.2 | 16.9 |

The O&LK subdivision of the B&O Railroad ran one first-class and three third-class trains between Parkersburg and Zanesville in 1951. This timetable shows distances, times, and rules for each stop. The trip to Parkersburg took 50 minutes from Marietta and cost 15¢. In 1903, the Parkersburg, Marietta, and Inter-Urban Co. was formed. It ran both the street car systems as well as the interurban line.

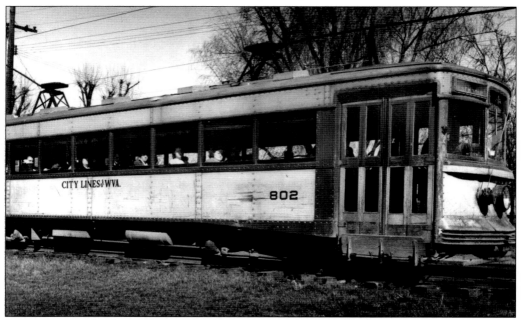

Rail passengers holding tickets to Marietta and arriving at Parkersburg, for which there were no convenient connections, were issued tickets upon request from the Sixth Street Station ticket agent to Marietta via the Monongahela West Penn Public Service Company. The Monongahela West Penn Public Service Company was the new official name of the interurban line, although local citizens still referred to it by its former name. The interurban hauled freight including hay, livestock, vegetables, and almost anything else. Passenger cars came and went almost every hour of the day.

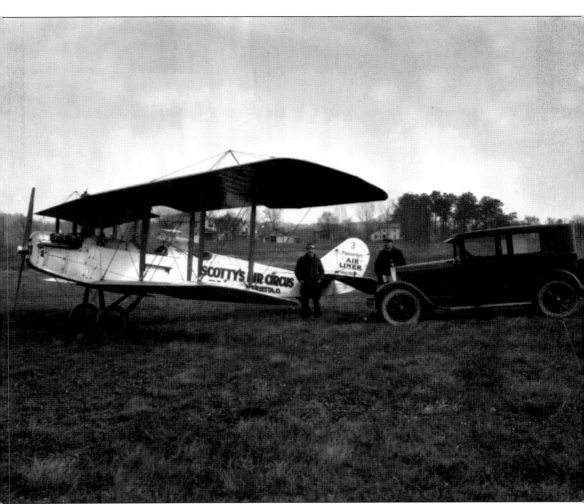

Marietta pilot Lyle Harvey Scott is pictured at Professor Swan's field along the Ohio River below Wayne Street in the early 1920s. Scott had an arrangement with Professor Swan to use his land as a flying field complete with hanger. The machine in the foreground is the *Curtiss JN "Jenny,"* which Scott purchased as WWI surplus for $50. Scott was born in Deersville, Ohio, in 1886. He went to Dayton, Ohio, in 1900 and took flying lessons from Orville Wright. Scott's favorite trick was to fly under the Ohio River and Muskingum Bridges. Scott is also remembered for doing loops over the Washington County Ohio Court House with his daughter, who was born in 1922. Scott died in an aerial circus performance at Arnettsville, West Virginia, in 1925. (WCHS.)

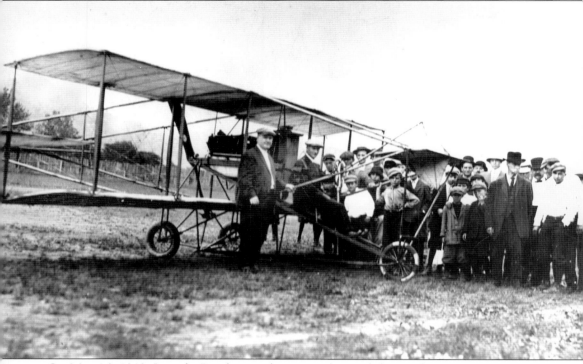

On May 16, 1912, Lincoln Beachey made two airplane exhibition flights at the Washington County Fairgrounds before a crowd of 700 people. Beachey was using a new plane for the first time, and it took two hours of test runs and three encounters with fences before he was able to maintain his ascent. His first successful exhibition run included racing a motorcycle driven by Robert Brenan. Beachey's second run included delivering a mail sack of 1100 letters and 400 post cards already cancelled by postmaster Ava Davis McCoy. The delivery was from the Fairgrounds to the post office. McCoy and other dignitaries hurried to the post office ahead of Beachey and watched as the mail sack landed in the lockmaster's yard next door.

# *Six*

# GLIMPSES OF NEIGHBORS

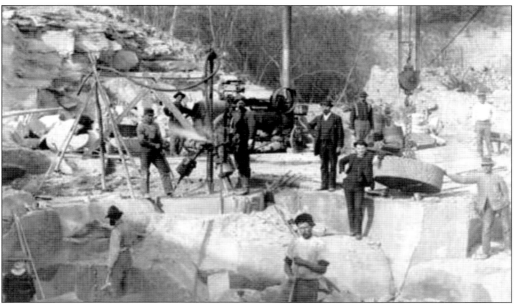

For 150 years, the sandstone-grindstone business thrived in Washington County, Ohio. The industry began there in the first two decades of the nineteenth century, supplying settlers, lumbermen, and the thriving Cincinnati edge-tool trade. Grindstones were hauled by oxen to the river's edge where they were loaded on flatboats and bound downriver or transported via steamboats upriver. Ephraim and Will Cutler were among the earliest to quarry grindstones. Rail transport replaced water in the mid-century. Local industry grew rapidly when Michael J. O'Connor bought out the Cutler operation and renamed it the Constitution Stone Company. The decline and end of the business came when synthetic abrasives became more efficient at high metal-grinding speeds. The Constitution Stone Company closed in 1970, just one year shy of their 100th anniversary. Up until this time, Ohio had produced 90 percent of the 4.5 million tons of sandstone-grindstones for the U.S.

| | Barlow. | Belpre. | Beverly. | Bonn. | Buell's Lowell. | Cedarville. | Coal Run Village. | Cow Run P. O. | Cutler. | Dalzell. | Germantown. | Grand View. | Harmar. | Macksville. | Marietta. | Matamoras. | Newport. | Pleasanton. | Salem. | Vincent. | Watertown. |
|---|---|---|---|---|---|---|---|---|---|---|---|---|---|---|---|---|---|---|---|---|---|
| Barlow | | | | | | | | | | | | | | | | | | | | | |
| Belpre | 13.9 | | | | | | | | | | | | | | | | | | | | |
| Beverly | 11.8 | 25.7 | | | | | | | | | | | | | | | | | | | |
| Bonn | 23.1 | 23.5 | 18.1 | | | | | | | | | | | | | | | | | | |
| Buell's Lowell | 14.5 | 22.7 | 9.5 | 8.6 | | | | | | | | | | | | | | | | | |
| Cedarville | 11.9 | 2.0 | 23.7 | 25.5 | 24.7 | | | | | | | | | | | | | | | | |
| Coal Run Village | 15.8 | 29.7 | 4.0 | 14.1 | 5.5 | 30.2 | | | | | | | | | | | | | | | |
| Cow Run P. O. | 20.9 | 21.3 | 23.5 | 10.0 | 14.0 | 23.3 | 19.5 | | | | | | | | | | | | | | |
| Cutler | 9.8 | 16.5 | 21.6 | 34.4 | 24.3 | 14.5 | 25.6 | 32.2 | | | | | | | | | | | | | |
| Dalzell | 29.2 | 29.6 | 24.2 | 6.1 | 14.7 | 31.6 | 20.2 | 10.6 | 39.0 | | | | | | | | | | | | |
| Germantown | 28.9 | 29.3 | 23.9 | 5.8 | 14.4 | 31.3 | 19.9 | 13.1 | 38.7 | 2.5 | | | | | | | | | | | |
| Grand View | 40.7 | 41.1 | 48.3 | 30.8 | 38.8 | 43.1 | 44.3 | 20.8 | 52.0 | 17.2 | 19.7 | | | | | | | | | | |
| Harmar | 11.6 | 12.0 | 20.2 | 11.5 | 10.7 | 14.0 | 16.2 | 9.3 | 22.9 | 17.6 | 17.3 | 29.1 | | | | | | | | | |
| Macksville | 33.9 | 34.3 | 18.2 | 10.8 | 9.8 | 36.3 | 14.2 | 20.8 | 34.1 | 12.9 | 12.8 | 30.1 | 22.3 | | | | | | | | |
| Marietta | 12.1 | 12.5 | 19.7 | 11.0 | 10.2 | 14.5 | 15.7 | 8.8 | 23.4 | 17.1 | 16.8 | 28.6 | 0.5 | 21.8 | | | | | | | |
| Matamoras | 41.7 | 42.1 | 49.3 | 31.8 | 39.8 | 44.1 | 45.3 | 21.8 | 53.0 | 17.3 | 19.8 | 1.0 | 30.1 | 31.1 | 29.6 | | | | | | |
| Newport | 27.3 | 27.7 | 34.9 | 18.7 | 25.4 | 29.7 | 30.9 | 8.7 | 38.6 | 19.3 | 21.8 | 13.4 | 15.7 | 37.0 | 15.2 | 14.4 | | | | | |
| Pleasanton | 8.5 | 22.4 | 18.0 | 31.6 | 20.7 | 20.4 | 22.0 | 29.4 | 6.0 | 35.4 | 35.1 | 49.2 | 20.1 | 30.5 | 20.6 | 50.2 | 35.8 | | | | |
| Salem | 25.9 | 26.3 | 18.4 | 2.8 | 8.9 | 28.3 | 14.4 | 12.8 | 32.2 | 6.9 | 6.6 | 33.6 | 14.3 | 8.0 | 13.8 | 34.6 | 21.5 | 29.6 | | | |
| Vincent | 1.5 | 12.4 | 13.3 | 24.6 | 16.0 | 10.4 | 17.3 | 22.4 | 9.8 | 30.7 | 30.4 | 42.2 | 13.1 | 35.4 | 13.6 | 43.2 | 28.8 | 10.0 | 27.4 | | |
| Watertown | 5.0 | 18.9 | 6.8 | 18.1 | 9.5 | 16.9 | 10.8 | 20.6 | 14.8 | 24.2 | 23.9 | 40.4 | 11.3 | 19.3 | 11.8 | 41.4 | 27.0 | 11.2 | 18.4 | 6.5 | |

This is the "Table of Distances for Washington County, Ohio." Charts of this type would have been used by commercial transporters to determine shipping cost and delivery times for customer orders. Most of the county could be reached in under a day by horseback during the pioneer days, which was especially important during times of emergency and in warding off hostile forces. The longest distance between two points in Washington County is between Pleasanton and Matamoras at 50.2 miles.

Clarinda "Sis" J. Knowlton and others stand at the head of the steps to her post office at Wade, Independence Township, c. 1930. Sis kept the post office for 38 years, 1897–1934. The Township of Independence was established in June 1840. The first post office in Independence was called Ostend meaning "east end" in German. It was built in 1842 with blacksmith Stillman Harvey serving as the first postmaster. Ostend mail was first picked up by the Marietta-Wheeling stage coach and later by steamboats. William Rea Jr. became the second postmaster in 1847. Squire Dilly Riggs took over in 1864 and had the name of the office changed to Wade in honor of Benjamin Franklin Wade, the United States senator.

Marianne Hadger poses in front of her post office in 1910. On the Little Muskingum River near Reno stood the post office of Dell. Henry M. Hill was appointed postmaster in July 1884. The post office was discontinued on June 19, 1886. It reopened on June 29, 1886, in the store of Thomas Pegg. Pegg's store burned in 1899, and the Post Office moved into the store of Daniel Hadger, where his wife Marianne was appointed postmaster.

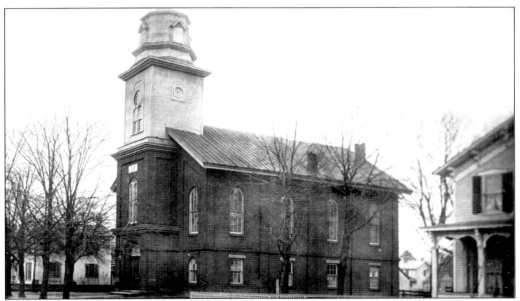

The congregation of the Belpre Congregational Church celebrated its 175th anniversary on May 19, 2002. The church's long history in Belpre began in 1827 when the church was granted a charter for a congregation. The new church was built on the west end of Rockland Cemetery. By 1868, another building was constructed on Main Street in Belpre. This church building has remained relatively unchanged for 175 years. The only major additions are the 1901 pipe organ from another local church and an elevator. This photograph was taken in 1863.

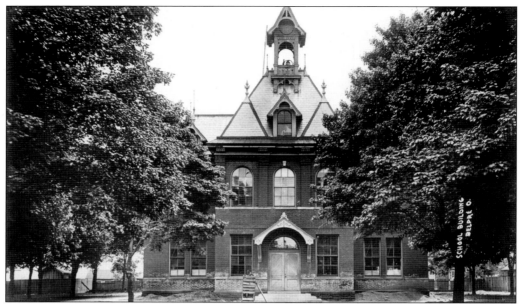

Built in 1875 at the cost of $3300, the Main Street School Building in Belpre is shown here in 1920. In 1907, four rooms and an office were added. After 1929, it was used as a grade school after a new high school was built. This stately building was remodeled and repaired between the years of 1941 and 1942. It was sold and used for storage in 1969. Notice the flood marks under the first floor windows.

On March 24, 1838, the Beverly Post Office opened in the Beverly House, a tavern owned by Frederick B. Riheldarfer. Mr. Riheldarfer is not credited historically as being the first postmaster, as he was arrested, went bankrupt, and moved out of town. John Keyhoe is the first historically recognized postmaster of Beverly. In 1883, the post office moved to Wm. H. Langenberg's Tannery on Fifth Street. By 1897, the post office was located downstairs from the *Beverly Dispatch* newspaper office and next door to James P. Snoops Grocers on Fifth Street. The building is now the Fraternal Order of Eagles Lodge.

Once again, the Beverly Post Office moved. This time it was located next to Dr. Funk's drug store. James R. Ball was the postmaster, and Samuel Bailey and Glenna L. Wagner assisted. Richard Jones and Virgil Rowlands were the first rural mail carriers. In 1960, the post office moved to Ohio 60. The latest post office in Beverly was built in 1999 near the former office.

In Beverly, Ohio, in 1838, Benjamin Dana bequeathed land for an academy to be built. In 1842, John Dodge of Beverly also deeded several lots to the Reverend Charles R. Barclay for establishing the Muskingum College (afterward called Beverly College). A three-story brick building was erected for the intended college. The college continued until around 1900. In 1920, Saint Bernard Roman Catholic Church owned the building. In the 1950s, it was torn down and replaced by the present Saint Bernard Church. The location was on the north side of Seventh Street in the middle of the block across from Dodge Park.

## Population by townships and towns:

| | 1840 | 1880 | 1890 | 1900 |
|---|---|---|---|---|
| Adams, including Lowell....... | 791 | 1856 | 1724 | 1495 |
| Lowell....................... | | | 441 | 381 |
| Aurelius, including Macksburg... | 886 | 999 | 1394 | 1254 |
| Macksburg................... | | | 533 | 448 |
| Barlow...................... | 880 | 1200 | 1271 | 1454 |
| Belpre... ................. | 1296 | 2636 | 2678 | 2761 |
| Decatur..................... | 439 | 1504 | 1493 | 1276 |
| Dunham..................... | | 900 | 962 | 1021 |
| Fairfield.................... | | 731 | 725 | 758 |
| Fearing..................... | 1019 | 1275 | 1027 | 939 |
| Grandview, including New Mata- | | | | |
| moras................... | 514 | 2663 | 2466 | 2832 |
| New Matamoras............... | | | 590 | 817 |
| Independence............ ..... | 335 | 1792 | 1611 | 1632 |
| Lawrence.................... | 571 | 2335 | 1799 | 1726 |
| Liberty..................... | 515 | 1614 | 1556 | 1461 |
| Ludlow..................... | 539 | 1375 | 1218 | 1237 |
| Marietta, including the city..... | 2689 | 8830 | 9944 | 15764 |
| Marietta city................. | | | 8273 | 13348 |
| Muskingum.................. | | | 1192 | 1204 |
| Newport .................. | 1678 | 2548 | 2405 | 2564 |
| Palmer ................... | | 591 | 541 | 614 |
| Salem...................... | 881 | 1638 | 1571 | 1500 |
| Warren... .................. | 931 | 1903 | 1709 | 1813 |
| Waterford, including Beverly... | 1166 | 2128 | 2370 | 2269 |
| Beverly..................... | | | 795 | 712 |
| Watertown.................. | 1128 | 1894 | 1363 | 1348 |
| Wesley............... ....... | 991 | 1402 | 1361 | 1323 |

The total population of Washington County grew by approximately 272 percent from 1840 to 1900. The population rose from approximately 17,249 to 63, 951. The largest segments of the population growth were primarily along the periphery waterways of the County and the City of Marietta. The population growth matched the increased economic optimism created by the new industry and oil production in Washington County. The central portions of the County remained relatively static during this time.

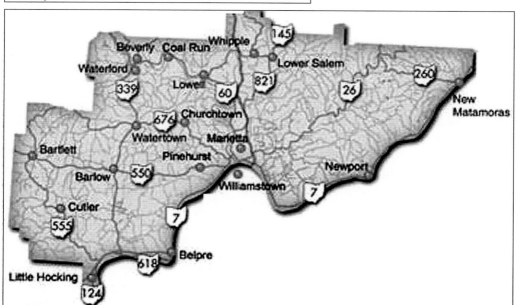

Washington County was established on July 26, 1788, and now encompasses 635 square miles. The total population of Washington County in 2000 was 63,251, remaining relatively stable since 1900, with the total population density at approximately 100 persons per square mile. The population was approximately 97 percent caucasian during the 2000 federal census, and it was 98.2 percent caucasian during the 1990 federal census. The largest single minority group was African American, representing 1.7 percent of the population. Other minority groups represented were Native American, Asian, and Pacific Islander.

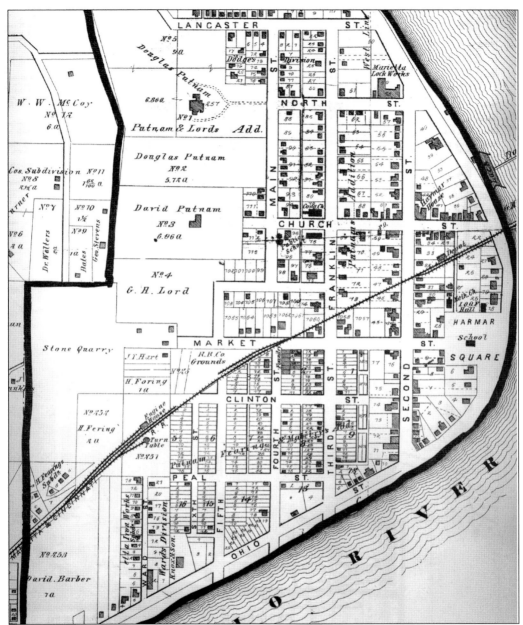

Fort Harmar was established in 1785, three years before settlers came to Marietta in 1788. The U.S. Army had established an outpost to protect settlers from Native Americans who already lived in the region. In 1825, when Marietta received a charter, Harmar was considered the city's second ward. But by 1835, the residents of Harmar had separated from Marietta to become a village. By the late 1800s, an alliance began to look more attractive to the two municipalities. In April 1890, the voters of Harmar decided to reunite with Marietta by a 90-vote margin. In 1880, the population of Marietta alone was 5,444. The population of Harmar was 1,571. By 1900, after the annexation, Marietta had grown to 13,348. Pictured above are Harmar's property boundaries, c. 1875.

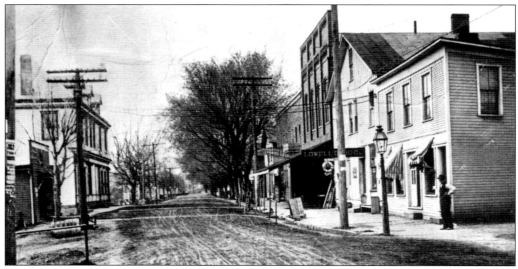

This photograph was taken only a few days before the great flood of 1913. This view facing north shows North Canal Street, the H. Reitz and Co. general store, Paul Heckman's Saloon, and Dr. Glass' dentist office. The *Lowell Record* newspaper was run by Spencer Kile. Art Stanley was the druggist, jeweler, and postmaster. On the left are a bank and a barbershop.

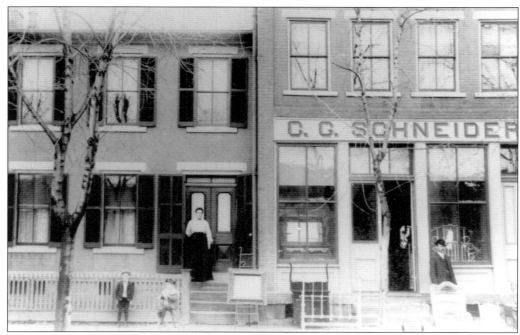

In 1869, Franz Schneider built a furniture store and funeral parlor on Main Street in Lowell. The Valley Hotel was next door. The furniture store was on the first floor, and the funeral home was on the second. The Masonic Lodge, chartered in 1869, used the third floor. The Schneider family lived on the other side of the store in the two-story building. Chris Schneider, son of Franz, continued the business until 1913 when he sold it to Henry Spies and his son George. In 1947, he sold the business to Robert Peoples. The building was demolished in the late 1980s.

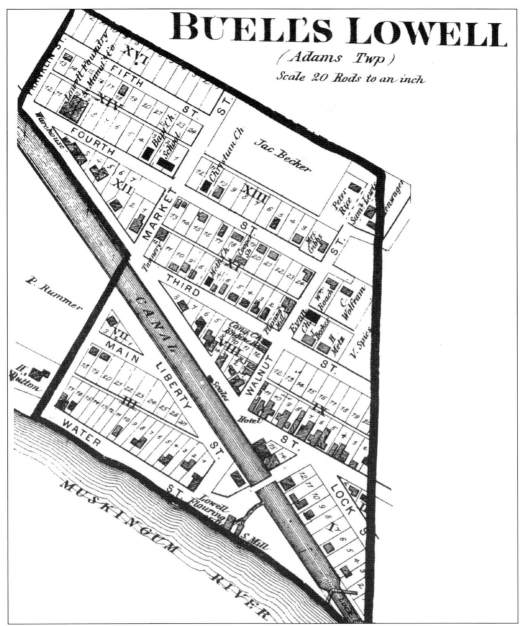

# BUELL'S LOWELL

(Adams Twp)

Scale 20 Rods to an inch

The first settlers in the Lowell area were pioneers from Marietta. The Ohio Company of Associates received a donation of land about 14 miles up the Muskingum River, and settlers were to be assigned 100-acre surveyed plots. The land donation was meant to induce settlers to choose this area after the "Native American Massacre" at Big Bottom had discouraged new settlement. Settlers were required to build a house within five years, clear 20 acres of land, and defend against Native Americans. In April 1795, four families and four single men moved into a fortified settlement near the south end of the Muskingum River Bridge at Lowell, know as Kinney Garrison. Perez Barnum Buell was the founder of Buell's Lowell in 1838. It was not until 1889 that the town council changed the name to Lowell. The first store in Lowell was opened by Elijah Short in 1822.

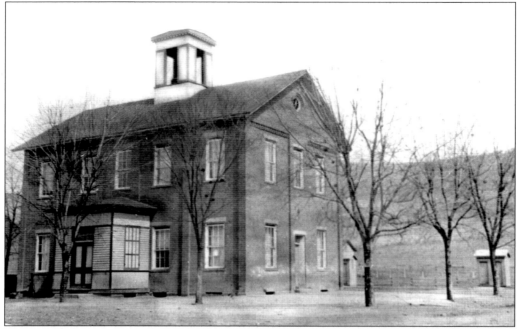

The establishment of schools and churches was a priority in the life of early settlers. Early schools were supported by subscriptions of patrons. The first school built in Lowell was a two story brick building erected at the corner of Fourth and Market Street in 1854. Lowell's first graded school with high school courses was established in 1888. This photograph shows the old Lowell school c. 1910.

In 1873, John Hopp started a blacksmith shop in this building. This c. 1895 photograph was taken before the second story was added to the building. The sign on the corner of the building advertises, "Buggies, carts, carriages, surries, praeons, and spring wagons." "Arbuckles coffee" is painted on the sign by the door.

Art Hopp began running the blacksmith shop with his dad. He continued to run it until the late 1950s when his son Fred became the operator. After Fred retired, his son Richard ran the business. The building was burnt down in the late 1950s, and the new Lowell (LA) fire department was built on the lot. At the time this photograph was taken, John Hopp and Son had diversified their business to include Studebaker sales along with Troy wagons.

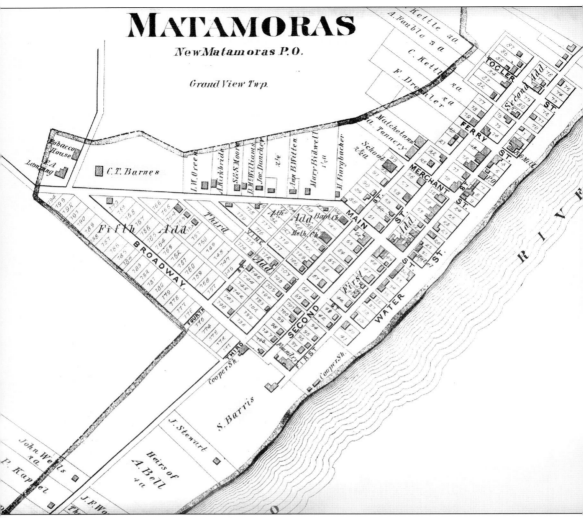

# MATAMORAS

### New Matamoras P.O.

*Grand View Twp.*

Part of Matamoras Village's heritage is having two names. Matamoras, the town, is located in Grandview Township in Washington County. New Matamoras is the name of the post office. The first families to settle on the site of Matamoras arrived in 1797. Henry Sheet, Stinson Burris, and Adam Cline chose the highest available sites on the banks of the Ohio River. The Village of Matamoras itself was not platted until 1846. Adam Cline did not file his plat until 1850. Fifteen years later, in 1861, the mayor and council of Matamoras applied for and received a post office. However, the U.S. Postal Service refused to issue the name "Matamoras" for fear it would be confused with Metamora in Michigan. . . . now you know the rest of the story.

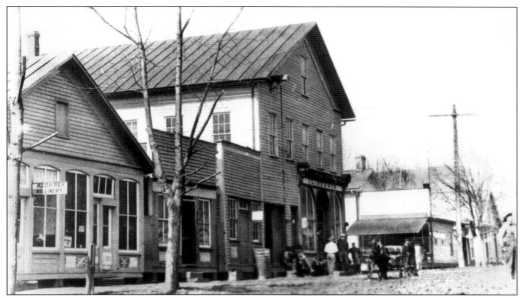

Matamoras, as well as all of Washington County, experienced abundant prosperity in the 1920s. First-rate movies were shown at the Palace Theatre. During the early 1900s, another source of entertainment were the showboats that plied the Ohio River. Previews of the evening performances were often given on the Matamoras streets during the day by performers. Cline and Son stood at the corner of Second and Main Streets just two doors down from Adda Rea's Millinery, as shown here, c. 1910. In the same block were Grover Heddleson and George Harvey's insurance office.

To protect the not so innocent, this craggy fellow will remain anonymous. He and his still were found between Lowell and Matamoras in 1910. Homebrew saved many trips into town and was often preferred to the sample room fare. Staying at home also saved the lives of partakers, neighbors, and even horses and livestock.

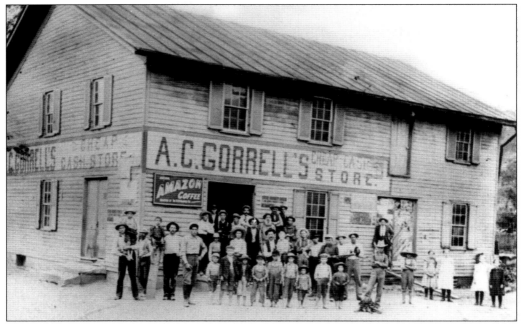

In 1875, A.L. Sears came from Marietta to open his own store in Coal Run. Mr. Sears ran the A.G. Gorrell's Cheap Cash Store for over 35 years. During this time, he and his wife Leora only had two helpers: Ronnie Lockard and Lucy Barton. Leora's father, Monte Burrows, was one of the proprietors in the business before Sears became the store owner. In its heyday, Coal Run, between Lowell and Beverly on Route 60, had a post office, three stores, two churches, a school, and a gas station. The people in this picture are unidentified.

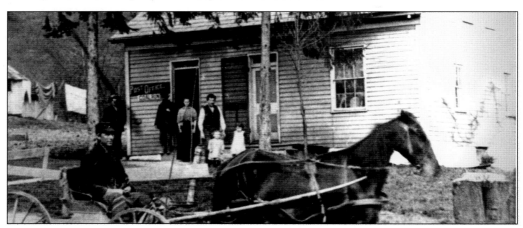

Coal Run received its name from two coal mines that once flourished and earned it the reputation of being one of the area's richest coal towns. Barges routinely docked along the Muskingum River, loading bituminous coal from the mines and river bed. Ferry service was available across the Muskingum, and there was access to the streetcar line between Beverly and Marietta. A blast furnace and foundry fires lit up the surrounding woods. Colonel Sam Beach owned a steam milling plant and distillery on the outskirts of Coal Run. Andrew Allison also owned a steam mill and distillery downriver from Coal Run. Allison was magistrate and a lawyer in addition to his other businesses. The citizens in this picture are also unidentified.

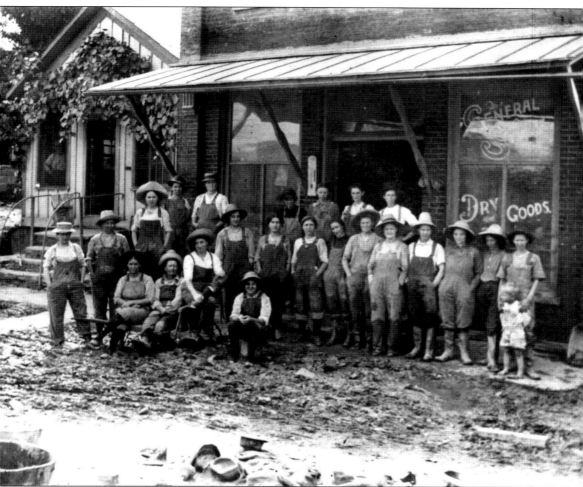

In late March 1913, an unusually heavy rainstorm moved into Ohio. It rained steadily for five days, and the streams throughout the state rose rapidly. By the third day of the downpour, levees were overrun, and many towns suffered disastrous flooding. Lower Salem, just north of Marietta on Ohio 821, was no exception. Kimnach's General Store and Dry Goods suffered along with other homes and businesses. Here, the women of the town take a break from the clean up effort to pose for a portrait. Kimnach's Dry Goods weren't dry anymore. Notice the men's hats piled in the street at the bottom of the photograph. Despite the futility of it all, the women still break into smiles.

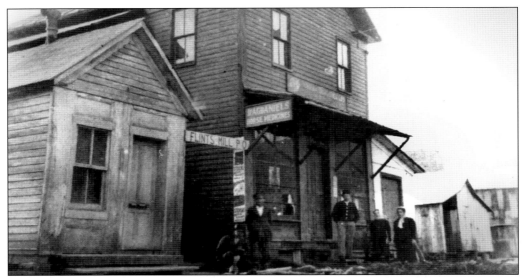

At the present north border of Washington County is the Ludlow Township. Israel Ludlow surveyed this land for the Ohio Company, and Ludlow Township was established in July 1819. The first post office was established in 1833 in Daniel Flint's store, which was the first store in the Township. This store was situated along the Little Muskingum River and opposite the mill erected before 1832 by Porter Flint. The post office received the name Flint's Mill and was taken over by Horace Holland in 1837. Porter Flint laid out the town called Bloomfield here in 1840, but the name Flint's Mill was retained for the Post Office, as there was already a Bloomfield Post Office in Ohio. Taken in 1915, this photograph shows the post office located next to Dr. A.G. Daniel's Horse Medicine shop.

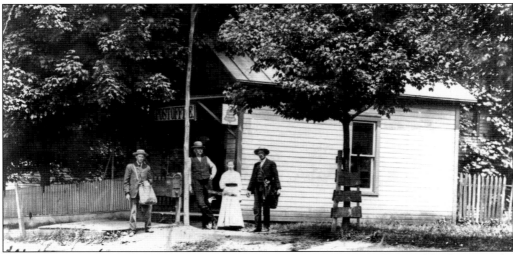

The Little Hocking Post Office was first established in 1824 as Little Hockhocking in the southwestern extreme of Belpre Township. "Hockhocking" is a Native American word meaning jug or cup. The first postmaster was Horace Curtis, who conducted postal business in his dwelling and later in his store overlooking the Ohio River. Alonzo Clifton was the postmaster from 1898–1914. Mr. and Mrs. Clifton are flanked by two rural delivery carriers in this 1907 photograph. Notice the mailbox on the post by Mr. Clifton.

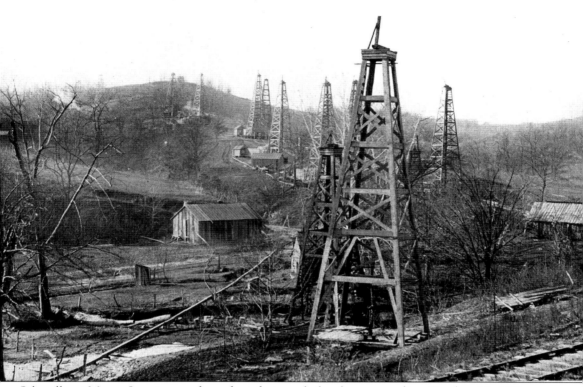

Oil wells at Moore Junction performed at their peak for the year ending October 21, 1901. Washington County sent to market 1,394,794 barrels of white sand oil, a daily average of 3,874 barrels. The Standard Oil Company laid all the pipe lines and built spumping stations, paying for the labor to care for their interests. The annual direct income from the oil industry was approximately $1,963,225. Wildcatters (speculative well drillers) were at work testing every township in the county at this time. Seven wells were producing on the east side of the Muskingum River and one on the west side. The county assessors reported that the total value of all the horses, cattle, mules, sheep, and hogs for the same year was $803,343—less than one-half the annual income from the oil industry!

The Cree House Hotel was located in Newport, Ohio. The Hotel operated from the 1850s to the 1880s. It was operated first by James Cree, then by D.H. Cree. As with many other towns, the post office was located within general stores or hotels. From April 10, 1863, until March 22, 1866, when Alfred P. Cree served as postmaster, the post office was located in the Cree House Hotel.

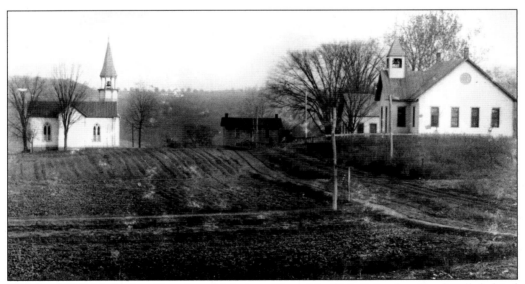

The Sand Hill Methodist Church and Marietta Township High School at Sand Hill, behind Reno, are shown c. 1905. The original Sand Hill Methodist Church was built by William Thorniley and Sons on property that was donated by the George Posey family in 1872. The first services were held on February 11, 1872. The building pictured here was built on the same site and was dedicated on November 18, 1900. The High School was built in 1885.

The Bartlett School is shown in Wesley Township in western Washington County, Ohio, c. 1895. The first log schoolhouse in Wesley Township was built in 1819 one mile north of Plymouth. Miss Hewitt served as the schoolmistress. The town was named after its first postmaster, Amos Bartlett. In 1960, Bartlett High School consolidated with the Warren Local School District. Bartlett High School became an elementary school, and students now attend high school at Warren High School in Vincent, Ohio.

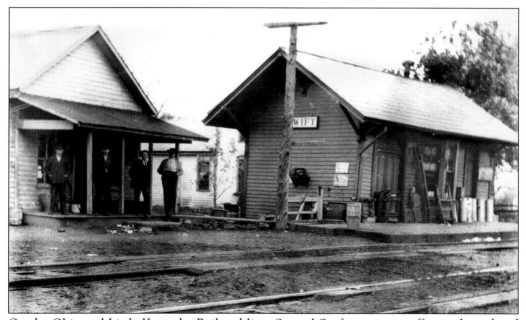

On the Ohio and Little Kanawha Railroad line, Samuel Swift ran a post office and a railroad station. This photograph was at Waterford Township, Washington County, c. 1908. Samuel Swift stands second from left.

The Waterford Cash Hardware Company sold stoves, paint, roofing, oils, varnish, and other hardware in 1912. Notice the gas and oil tanks on either side of the platform. The people on the platform are unidentified. Waterford Township, unlike many townships in Washington County in the early 1900s, did not enjoy great population growth. The Township only showed a 3,000 person gain in population from 1870 to the 1950 census.

Harry P. Fischer was born in Marietta in 1879. He attended the Muskingum Academy and then opened his own photography studio on Front Street in 1902. His sense of humor and ease with people were obvious in his work. Known for his industriousness, Mr. Fischer created hundreds of glass plates and over 14,000 negatives. Much of his work was documented in the post cards Mr. Fischer created and sold. Without Mr. Fischer's work, *Images of America: Marietta* would not be possible.

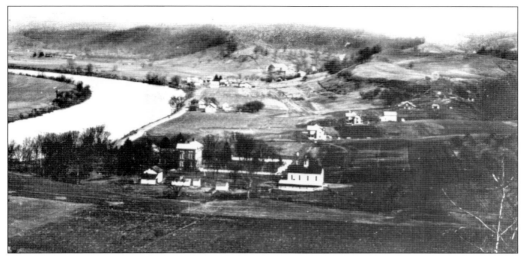

Just north of Marietta at the intersection of Routes Ohio 821 and Ohio 60 stands a green sign marking "Unionville." Tourists and newcomers passing through are left to wonder why this sign stands here when there are no inhabited buildings within 150 feet. This sign is a reminder of Unionville in its heyday in the late 1880s when approximately 30 families lived there. Formerly known as Pinchtown because its location was pinched between the rolling foothills of the Appalachian Mountains and the Muskingum River, the town's name was changed to Unionville around 1904. This aerial view shows the Children's Home and barn in the foreground. Unionville sits right at the bend of the Muskingum River.

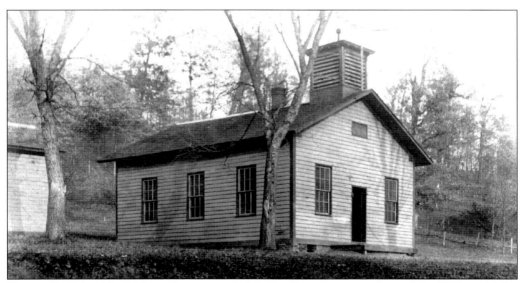

Unionville School had 25 pupils at its peak. Mr. Jim Devol was president of the PTA, and Mrs. Devol organized the 4H-Club for Girls. Businesses in Unionville before the devastating flood of 1913 included: John Grime's Wagon and Body Shop; Ed Weinstock's Blacksmith Shop; Pinchtown Mission No.1, where pastors from Marietta led Sunday services; and Bradley's Market and Livery. The flood of 1913 devastated the town. Residents salvaged what they could, and most moved into Marietta. A cinderblock building that still stands at the apex is all that remains of Elmer and Pearl Thrasher's Parkette 24-hour restaurant, which opened in 1952 and closed in 1983.

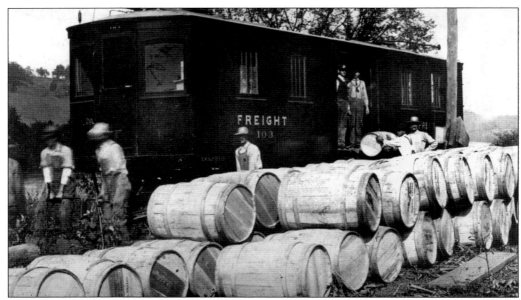

This photograph depicts workers at the M.H. Dyar and Son Apple Farm, three miles below Lowell at the Riverside Stop on the interurban rail line. At this time, apples were packed and shipped in barrels and consigned to Thornily Brothers Produce Co. Here the barrels are rolled up into the waiting Parkersburg and Marietta Inter-Urban Traction Co. freight car No.103. The apples were eventually shipped by packet boat to the markets in Pittsburgh and Cincinnati.

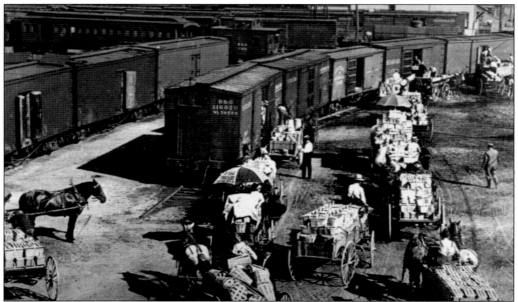

In the early 1900s, produce was driven by wagon from area farms to the B&O team track on Second Street. The box cars are reefers (refrigerated cars). The photograph is c. 1921. At that time, apples were packed and shipped in barrels, and sweet potatoes were transported in elongated baskets. Agriculture was a primary business in the region, and the farms around Marietta were known for their large apple orchards, maple sugar groves, and acres and acres of sweet potatoes.

# Seven

# RISING WATER

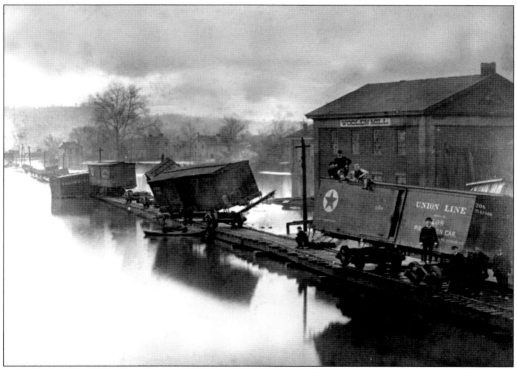

As the old Chinese proverb goes: "One picture is worth ten thousand words," and Harry Fischer hoped that his work on the 1937 flooding disaster of the Ohio River Valley would serve to wake up the Federal Government to the gravity of the need for flood protection. The U.S. Department of the Interior responded with a geological survey which stated that the cause of the flooding was "excessive precipitation." This report included comparisons with earlier floods. All reports listed the same cause for the flooding. The great flood of 1937 was not the last flood for the Ohio River Valley. Shown above is the Butler Street Trestle after the 1884 flood waters began to recede.

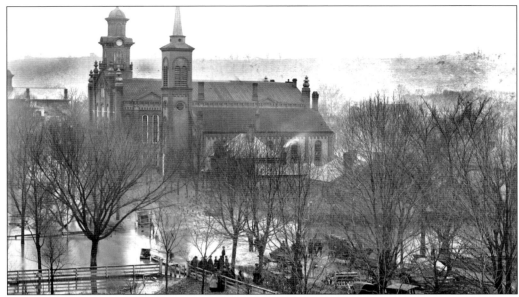

This is a view of Putnam Street during the February 9, 1884 flood. The citizens gather at the new boat ramp. Many people had gathered the items they could salvage and stored them in barrels stacked by the fence. In 1913, the U.S. Department of the Interior reported that in no year since 1810, when flood stages were first recorded, had the Ohio River failed to overflow somewhere along its banks, flooding adjacent inhabited lands.

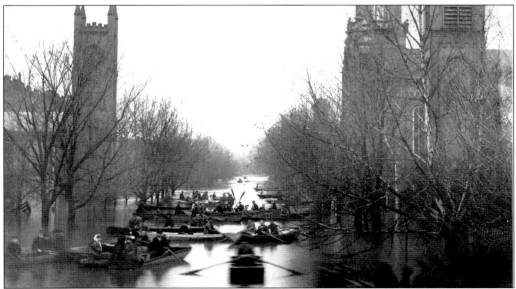

Here's another view of the corner of Fourth and Putnam Streets during the flood of 1884. Some of the people are waving in the background and one gentleman has his oars raised in order to be noticed. The U.S. Department of the Interior also reported in 1913 that for many years the Ohio River had overflowed its banks no less than five times each year. Further, this report stated that the problems connected with the improvement, regulation, and use of the Ohio River and its tributaries had been under consideration for more than a century.

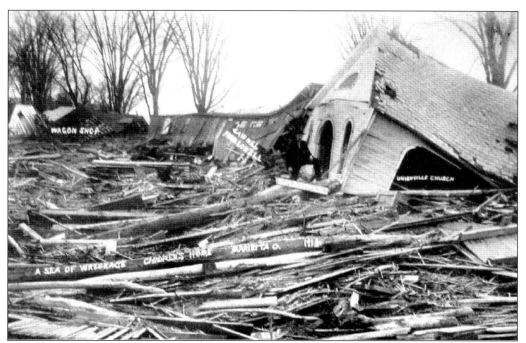

The flood of March 29, 1913, obliterated Unionville. The greater part of Unionville ended up in the yard of the Children's Home near Marietta. Here, the Unionville Church, a sawmill from Lowell, John Grime's Wagon Shop, and various other buildings create a sea of wreckage where Ewing School now stands beside the former Children's Home.

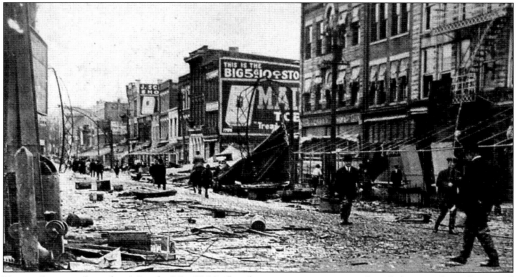

Front Street after the March 29, 1913 flood was a prime example of the results of natural disaster. Some businesses never recovered. The trolley tracks are the only clear path through the devastation. The city clock still stands on the far right hand side of the photograph. Business owners are beginning to board up their windows. The street arches are mangled and would be repaired within two months.

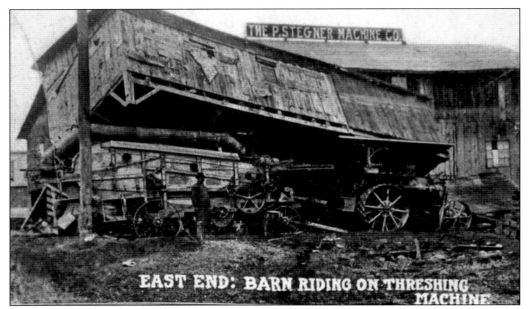

EAST END: BARN RIDING ON THRESHING MACHINE

The P. Stegner Machine Company in Marietta ended up with a barn on top of a threshing machine in for repairs when the March 29, 1930 flood occurred. This is just an example of the force the rising waters exerted on structures in the Ohio River Valley. The Department of the Interior concluded that there was no consensus on the solution to the flooding problem due to differences of opinion concerning treatment of the problem.

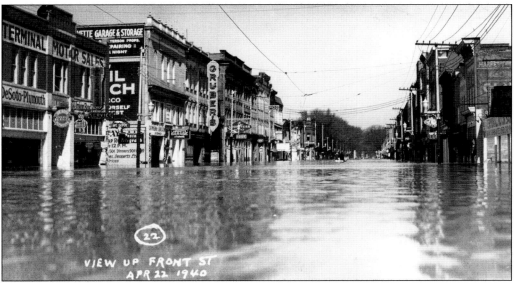

VIEW UP FRONT ST APR 22 1940

When the flood waters receded, the destruction was staggering. Tons of mud and debris covered the streets, homes, businesses, and factories. The buildings in the heart of the town were either burned or swept away, and the bridges were gone or severely damaged. There was no fuel to dry the houses or warm the people. In Marietta, 984 families lived in the flooded part of the city; 6,000 people were affected. Property loss in Marietta was estimated at more than $1 million after many of the floods.

104

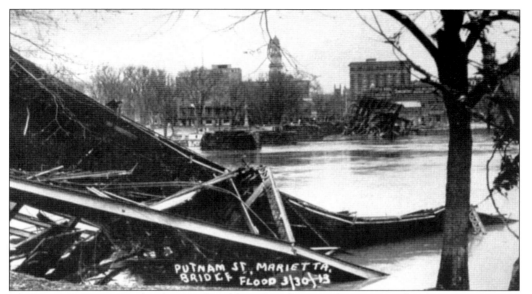

The Putnam Street Bridge lies in shambles after the March 29, 1913 flood. A ferry is seen moored near the bridge to transport refugees and possessions. Insufficient data was pointed to as the cause for the differences of opinion within the Department of Interior regarding solutions to the flooding problem. A new system was to be developed to study future accuracy and reliability of data. Government studies continue today.

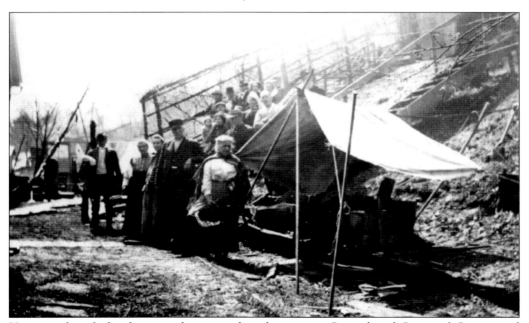

Here, unidentified refugees gather near their lean-tos at Second and Scammel Streets and commiserate after the March 29, 1913 flooding. The woman in the foreground is carrying all her eggs in one basket. Many people were displaced for months. Statewide, the death toll stood at 361, property damages were well over $100,000,000, and 65,000 people were forced to temporarily leave their homes.

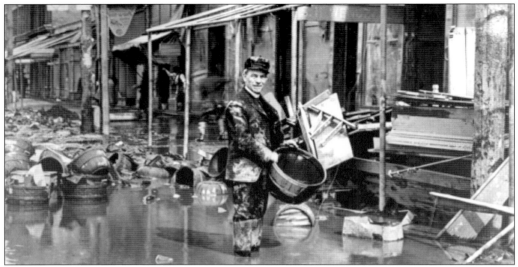

Showing true Mariettan resilience, the Reverend Elijah Coil smiles in the middle of devastation after the March 29, 1913 flood. Coil (1858–1918) was a minister of the First Unitarian Universalist Society in Marietta from 1895 until his death in 1918. He was known for his forceful sermons and his poetry. He attended Union Christian College in Indiana and was a graduate of Antioch College in Yellow Springs. He was also postmaster of the American Union Lodge No.1 F&AM (Free Masons). He was vice president of the Marietta Board of Education at the time of his death.

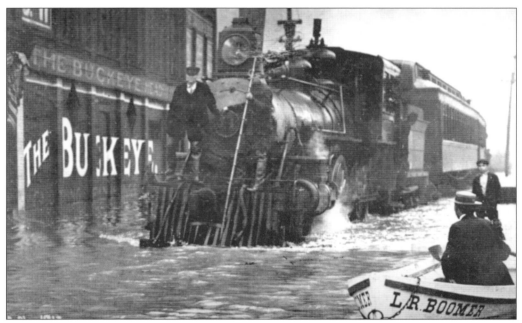

The well-remembered last train from Marietta is photographed near the intersection of Front and Butler Streets. The Buckeye Clothing store is on the northeast corner. Note the men on the cow-catcher with bamboo probing sticks to make sure the locomotive had track to run on during the January 13, 1913 flood.

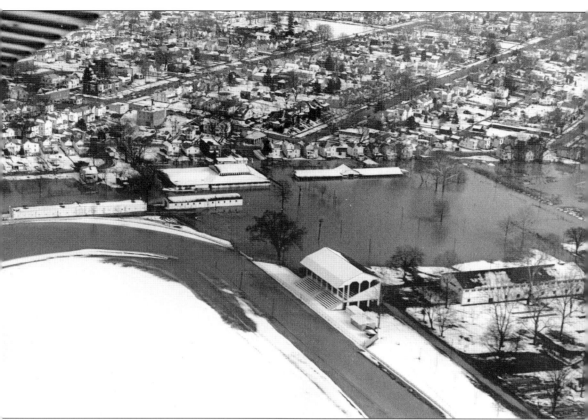

An aerial view taken by S. Durward Hong of the Washington County Fairgrounds during the flood of January 1937 shows all that remains above water is the skating rink and grandstand. Although Marietta did not suffer in this flood to the extent that other cities did, this flood covered 46 percent of the city. The entire business district was under 8–16 feet of water, and many of the historic churches had 4–8 feet of water in them.

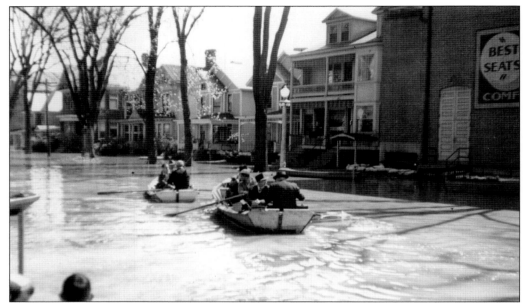

Unidentified service station attendants row businessmen down Third Street during the flood of January 1943. In the 1930s and 1940s, it was commonplace for Mariettans to keep Jon boats under their front or back porches. The local joke said that residents should keep handy a boat big enough to move their piano. The most widely known eatery in Marietta, the Leader Restaurant, always continued to serve coffee until water was past knee deep.

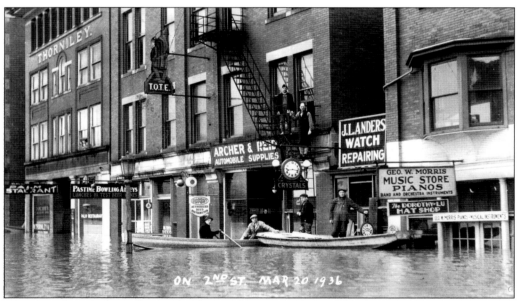

These unidentified gentlemen hold their boats together while the photographer snaps the photograph during the March 20, 1936 flood. Water taxis were abundant during floods. Shown here are the Palm Restaurant; Pastime Bowling Alley, with a sign advertising, "Lunches, Test Beers, and Wines"; Archer and Reid Automobiles Supplies; J.L. Anderson Watch Repairing; the Dorothy Lu Hat Shop; and George M. Morris Pianos and Musical Instruments shop.

# Eight

# MOMENTS IN TIME

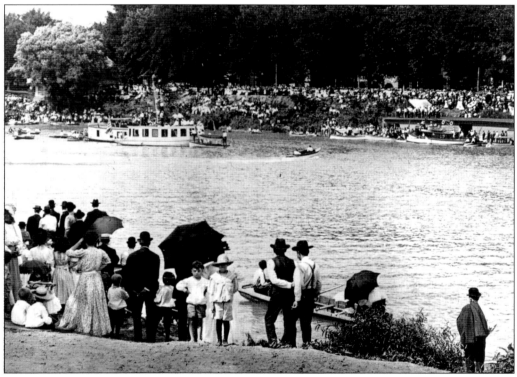

Entertainment on July 4, 1908, in Marietta, Ohio, included gathering at the riverbank of the Muskingum River for a water carnival. On July 4, 1777, Philadelphia marked Independence Day by adjourning Congress and celebrating with bonfires, bells, and fireworks—the custom eventually spread to other towns. During the Revolutionary War, the holiday was celebrated with rifle and cannon salutes. Observations throughout the nation became even more common at the end of the War of 1812. In 1941, Congress declared July 4th a federal holiday.

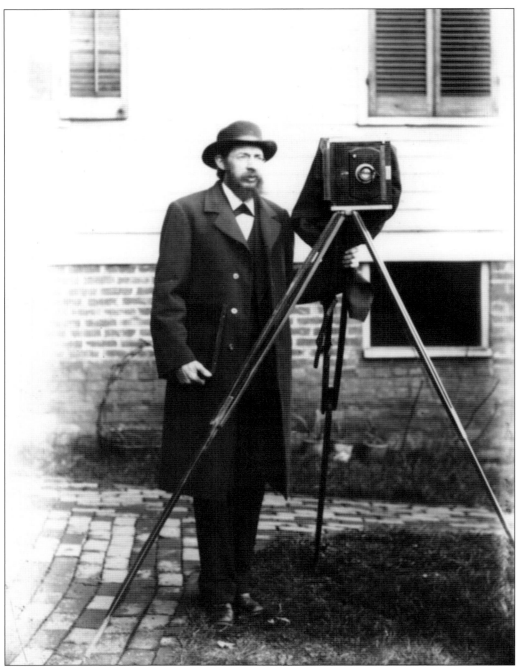

Photographer Thomas Dwight Biscoe holds steady with his equipment. Biscoe (1840–1930) was born in Grafton, Massachusetts. He moved to Marietta in 1874 and was a popular professor of the sciences at Marietta College. He developed homemade glass plates in a photography studio in his home at 404 Front Street. Photography was a laborious process for both the photographer and the subject. The photographer needed to calculate the amount of time required to expose plates, and subjects were required to stand motionless for great periods of time.

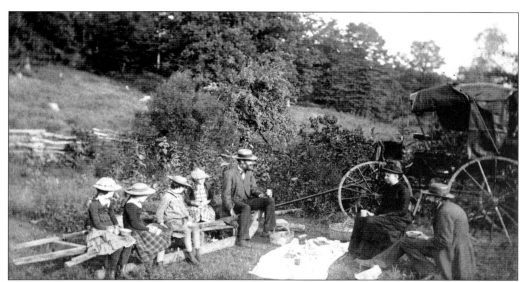

On September 1, 1885, Alice Biscoe, M. Andrews, Mrs. Andrews, Winifred Palmer, Louise Chamberlain, W.R. Andrews, and Professor Biscoe enjoyed a picnic. J.D. Cadwallader of Front Street took their portrait. Professor Biscoe was a student of J.D. Cadwallader, the most notable photographer in Marietta in the mid to late 1800s.

Here's the darling class portrait of Elizabeth Hill Sleigh's kindergarten class of 1894. At this young age, the children are still dressed alike, making it difficult to tell the girls from the boys, including, as follows: Grace Kirby, Phil Grafton, Aurelia Curtis, Eloise Grafton, Allen Nye, Bessie Sugden, Carol Weis, Walker Nye, Mabel Moore, Margaret Moore, Philip Best, Nelly Grimes, Wm. O'Brien, Elizabeth Sleigh, Stella Cole, and Lide Moore.

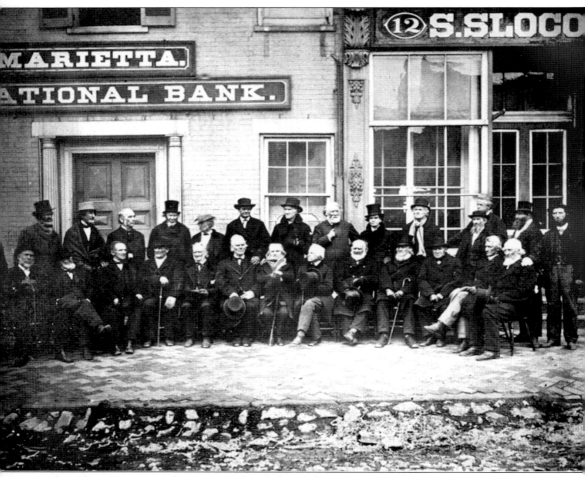

The Ohio Company of Associates decided in February 1789 to remember their landing with a special dinner and speech. Their resolution read, "Resolved that the seventh day of April be forever considered a day of public festival in the Territory of the Ohio Company as their settlement in this country commenced on that day." The first speaker was Dr. Solomon Drown, and this dinner started a tradition of speakers that continues to this day, taking place on April 7th in Marietta. The early celebrations were carried out by the members of the Pioneer Association of Washington County, a group of descendents of the original pioneers. Pictured above are the members of the Pioneer Association of Washington County meeting of 1869, left to right, as follows: (front row) John L. Brown, Joseph Hall, Henry Fearing, James Dutton, Silas Hubby, E.S. McIntosh, B.F. Stone, Augustus Stone, Weston Thomas, John Mills, A.T. Nye, O. Rice Loring, and Merritt Judd; and (back row) Ichabod Nye, Thomas Evart, Henry Hay, Douglas Putnam, Silas Slocumb, John Fest, Edwin Guthrie, George Barker, W.R. Putnam, Samuel Shipman, Joel Deming, Henry Corner, J.M. Woodbridge, Louis Leonhart, and J.P. Sanford.

Women started their own group, the Women's Centennial Association of Washington County, Ohio, in November 1886 when the Pioneer Association Citizen Committee refused to allow the ladies representation. The Women's Centennial Association refused to offer further support to the traditional April celebration. This photograph shows members of the Pioneer Association at the April 7, 1883, meeting at the City Hall Auditorium. Notice Rufus Putnam's portrait hanging on the stage.

"Out-Mount Campers Club" took a two-week camping trip in August 1886 at Camp Riverside above Coal Run in Washington County. The privileged few still enjoyed 'roughing it' on camping trips—they took their cooks and maids so life would not be too difficult. The campers include as follows: Bess Dyar, unidentified, unidentified, Charles McIlyar, Gordon Devol, unidentified, Helen Devol, Ann Devol, Harry Chamberlain, Mrs Joseph Reckard, unidentified, unidentified, unidentified, Maggie Reckard, and Jessie Devol.

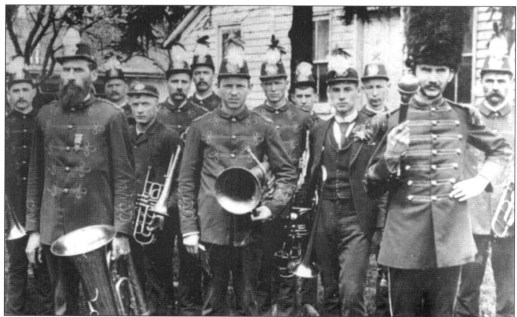

In the early 1900s, the Lower Salem Band held dances and gatherings in one of the upstairs rooms of a Lower Salem saloon. Lower Salem band members worked at the local tannery and steam sawmill, as well as at several of the stores in town. The Palmer Lodge No.351, Independent Order of Odd Fellows also included Lower Salem Band members.

Mrs. Effie Vaughn and her pupils pose for a class picture on March 2, 1909, at Unionville School. They are pictured as follows, from left to right: (front row) Nellie Grossland, Hollie Wellspring, Amy Close, unknown, unknown, unknown, Ethel Morgan, Daisy Morgan, unknown, Edythe Weinstock, Laura Weinstock, and Laura Morgan; and (back row) Rhoda Wellspring, Gloria Wellspring, unknown, Marie Steen, Ray Miller, Raymond Steen, Cornelia Grimm, unknown, Dorothy Close, Charley Morgan, and John Weinstock. At the time of this photo, little did Mrs. Vaughn and the other Unionville residents know their world would be turned upside down during the flood on March 29, 1913.

In 1910, Mrs. Mary K. Czotter's class performed the operetta *Cinderella* for Unionville residents. Cupid, in the front, was played by Margaret Dailey. The prince was performed by Gale Howard, and Cinderella was Dorothy Davis (both are wearing crowns). The girl dancers are: (left to right) Norma Howard, Mary Davis, Carol Galloway, Pearl Holder, Dorothy Dailey, and Helen Dailey. The boys are unidentified.

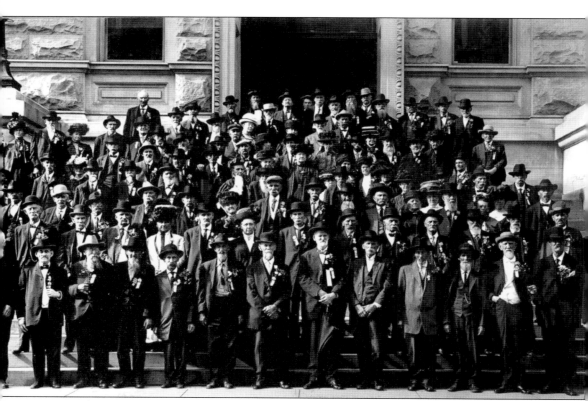

Around 1905, the "Reunion of Soldiers, Wives, and Widows of the War of the Rebellion 1861–1865" was captured in this photograph taken on the front steps of the Washington County Courthouse. Most members are wearing Company A, Ohio Volunteer Infantry ribbons. The buttons show a visual rendering of Abraham Lincoln.

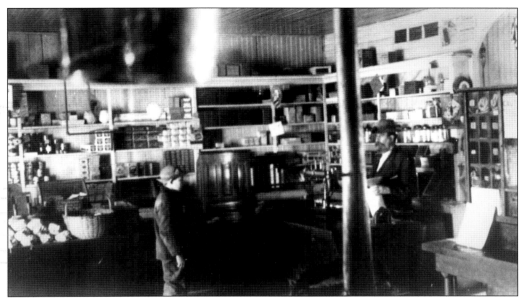

William D. "Billy" Root was the postmaster and storekeeper of the Gracey Post Office in Lawrence Township. Here, he is weighing some candy for a boy c. 1905.

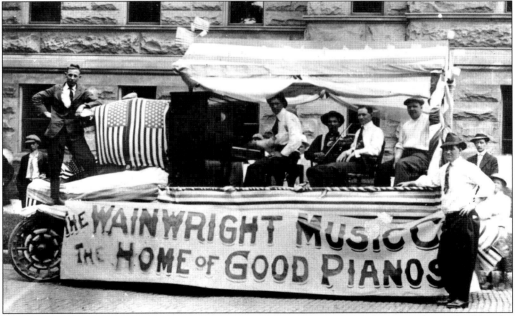

This Bessemer Truck is converted into a parade float for the July 4, 1916 parade. Parked by the Washington County Courthouse, the float advertises The Wainwright Music Co., "The Home of Good Pianos." Wainwright Music Co. began in 1908 when W.E. Wainwright opened a small shop at 342 Front Street. Soon after, the Steven's Organ and Piano Co. sold its Putnam Street location to Wainwright. Wainwright became one of the largest music firms in Ohio. Victrola and Victor Records were mainstays in the music business. Wainwright also sold ukuleles, violins, orchestral and band instruments, sheet music, player piano rolls, and Chickering pianos.

On two separate occasions, in 1910 and 1912, William H. Taft visited Marietta. The president spent four hours in Marietta on June 10, 1912, in conjunction with Marietta's Homecoming celebration and the Marietta College Jubilee for the college's 75th anniversary. The largest crowd to date had assembled in Marietta for this event, and picture postcards overflowed the post office after the event. Some 35 different photographs of the event were captured on postcards produced by Marietta photographer Harry Fischer. These postcards are easily found today by collectors. President Taft took the opportunity during this visit to view the original Ordinance of 1787 and other historic documents at Marietta College. He then led a parade to Muskingum Park where he gave the address shown here.

In celebration of Marietta's 150th anniversary, Mariettans put forth their best efforts to organize memorable celebrations. Federal funding was secured to finance the re-enactment of the journey of the pioneers. A group of men started from Ipswich, Massachusetts, in replicas of wagons used by the pioneers. This group duplicated the route of the pioneers. When the group reached what had been Sumrill's Ferry, Pennsylvania, they constructed replicas of the boats the pioneers used to travel down the Ohio River. They arrived in Marietta on April 7, 1938, and re-enacted the landing of the pioneers.

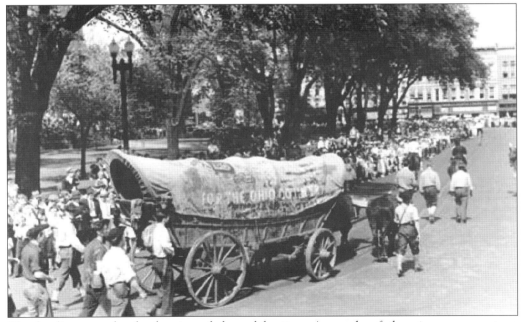

The landing was the focal point of the celebration. A parade of the pioneer reenactors, including their Conestoga wagon with "For the Ohio Country" painted on the side, proceeded to Municipal Stadium (now Don Drumm) for the five-day pageant, "Wagons West." A 150th anniversary costume ball rounded out the festivities. An additional festival was planned for July 15–19 to commemorate the organization of the Northwest Territory. Individual Day's activities honored each of the Northwest Territory states.

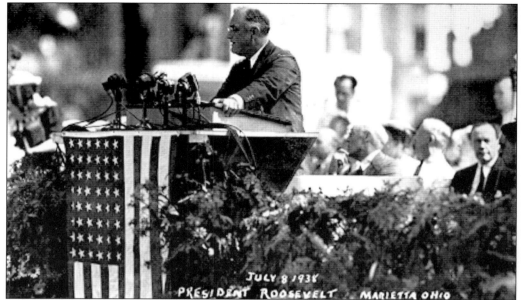

The second largest event in Marietta was the July 8, 1938 visit of President Franklin D. Roosevelt. President Roosevelt was originally scheduled to visit Marietta on July 13th, but complications in his schedule forced him to come to Marietta on July 8th. President Roosevelt spoke in Muskingum Park at the unveiling of the Borglum work *Monument to the Start Westward*. The French ambassador also spoke at the unveiling. The pageant, "Stars in the Flag," and a banquet rounded out the day's activities.

The Marietta Chamber of Commerce Board of Directors, 1939–1940, celebrates their 25th year. Their annual dinner was held at the Lafayette Hotel. Seated here are: (left to right) H.L. Sullivan, F.J. McCauley, A.L. Murray, B.E. Nida, Vice President I.J. Foulton, H. Guthrie Chamberlain, P.W. Griffiths, L. Glenn Seevers, H.E. Eversull, L.D. Strecker, Treasurer W.S. Eberle, W.E. Burns, Harry LeVan, Carl Broughton, Luther Toller, C.W. Stacy, Secretary Harry E. Schramm, and President Charles D. Fogle.

The Hotel Lafayette Gun Room dining room shows a typical lunchtime crowd *c.* 1947. On August 17, 1946, the Gun Room was formally opened to the public. Displayed on the walls were Durward Hoag's famous collection of long rifles. Also displayed throughout the Gun Room was a boat telegraph, steamboat steering arms, steamboat instruments, a bell, a compass, and bell pulls. The pilot wheels were made for the Navy in World War II, but were never used. These rifles were all handcrafted and date from 1795 to 1880.

Of all the movers and shakers in the past century in Marietta, Durward Steven Hoag was the most public-spirited and charismatic. Known to his friends as "Steve," Mr. Hoag was born in Binghamton, New York, on December 19, 1900. In 1918, his family moved to Marietta where he graduated from high school and attended two years at Marietta College. With a greater appreciation for history than most, Mr. Hoag succeeded in preserving the works of earlier local photographers and became an expert photographer himself. Hoag is credited with setting up the first Marietta historical tour and he maintained the county tour signs for years. He even published brochures showing points of interest in Marietta. Mr. Hoag served three terms as president of the Marietta Area Chamber of Commerce and worked for the Chamber, whether he was on the board of trustees or not. Steve Hoag was known to go to great lengths to create belly laughs at the expense of friends. His jokes included jacking up cars, drilling holes in water glasses, and filling closed umbrellas with corn flakes. In addition to managing the Lafayette Hotel, Steve Hoag was passionately interested in politics, writing, photography, and the promotion and preservation of Marietta.

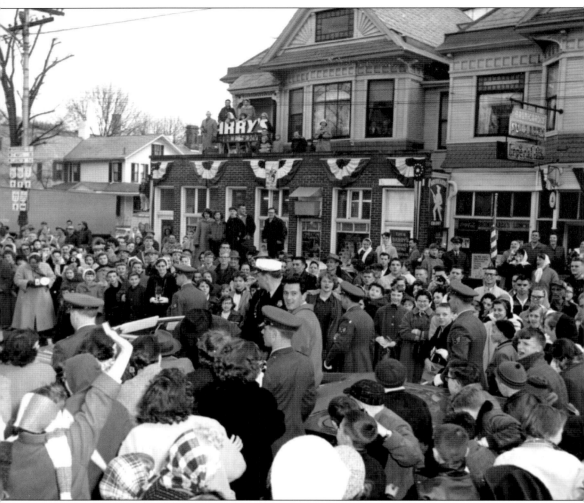

Rock Hudson is surrounded by adoring crowds during the parade for the premier of the movie *Battle Hymn*. Over 20,000 fans crowded into downtown Marietta on Tuesday, February 12, 1957, to see Rock Hudson, Jock Mahoney, and Dan Duryea. Marietta police and state troopers were overrun by screaming riotous teenagers and others who fought for Hudson's autograph, his coat buttons, hair, cigarette butts, and anything else they could grab. The *Battle Hymn* movie premier was the largest event in the city's history.

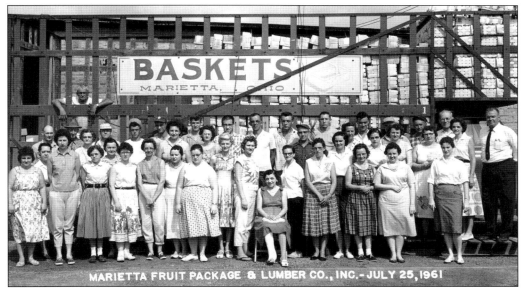

The Marietta Fruit Package and Lumber Co. began operations in January 1895. By 1916, they occupied 15,000 square feet of floor space. The facility even boasted one of Marietta's first automatic sprinkler systems. In 1900, the company manufactured fruit packaging, including banana crates and packing boxes. The company had its own printing plant for marking packages with the buyer's mark and also exported large quantities of packaging. In addition to the fruit package business, the company also sold lumber and building materials and did mill work.

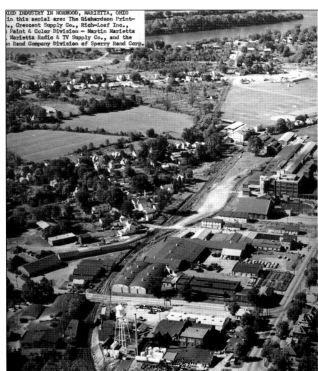

Durward Hoag took this aerial shot of the Norwood neighborhood of Marietta c. 1965. Diversified industry dominated this neighborhood near I-77 from the 1950 to the 1980s. Located in this view are the Richardson Printing Corp., Crescent Supply Co., Rich-Loaf Inc., Marietta Paint and Color Division-Martin Marietta Co., Marietta Radio and TV Supply Co., and the Remington Rand Co. Division of Sperry Rand Corp. A few of these businesses still reside here. (MACC.)

At the Lafayette Hotel in 1956, prominent businessmen of the Board of Trustees of the Marietta Chamber of Commerce pose for their yearly portrait, left to right, as follows: (front row) Treasurer R. Hobart Morris, Vice President F. Leonard Christy, President Durward Hoag, and Secretary John M. Penrose; (second row) Hayward W. Strecker, Harold W. Becker, Denver V. Harris, Robert Chutes, William Summers, and William McKinney; (back row) Max R. Farley, Frank D. Wagner, Ralph Brannan, Norman J. Murray, G. Sanford Guyer, Carl Broughton, and Fred W. Mains. (MACC.)

The governor's recognition of Marietta's national "Ohio's Most Historic and Beautiful City" award, was held in Columbus in March 1965. Governor James A. Rhodes, Publicity Director Richard McBane, First Ward Councilman Everett Hoff, and Clean-up Chairman John A. Burnworth pose with the trophy and scrapbook. Mariettans had campaigned hard for the previous three years to win this prestigious award. (MACC.)

The City of Marietta Police Department takes a break to pose for this formal photograph in December 1968. They include as follows, left to right: (front row) Chief P.K. Gramkow, Captain J.L. Barr, Traffic Clerk U.M. Arnett, Sergeant R.C. Morey, Sergeant H.A. Woodgerd, Sergeant J.F. Estes, and Sergeant G.S. Swaney; (second row) Mayor J.A. Burnworth, K.J. Reynolds, L.L. Warren, C.W. Durham, A.W. Thomas, R.E. McCracken, E.J. Kurtz, R. Sears, and S.S. Director L.R. Weber; (back row) B.R. Barlett, M.H. Turner, C.J. Argabrits, J. Malchiodi, E.A. Woy, D. Burge, D.H. Hahn, R. Phillis, W.J. Smith, and M.M. McCauley.

Ready to stop fires and save lives are the proud members of Marietta's Fire Department in 1968, left to right, as follows: (front row) Wm. McCrady, G. Wittekind, R. Clatterbuck, H. Lamb, J. Hegedus, B. Stanley, D. Medcalf, P. Siley, and D. Taylor; (middle row) Mayor Burnworth, J. Thomas, R. Wittekind, E. Vermaaten, G. Benson, P. Hale, G. Offenberger, F. Keerps, J. Boyce, C. Young, M. Karcher, B. Biehl, and L.R. Weber; (back row) R. Dutton, J. Matthews, and Wm. Eagleson.

Carl Broughton (1910–1996) is remembered for his love of the Marietta community and for his efforts to improve it for the people who lived there. In 1976, Mr. Broughton served as chairman of the "Committee of '76," to encourage businesses to locate in the downtown area and to make it more appealing to consumers. Within a year, the restoration effort had completed 13 projects and received applications for 60 more. Mr. Broughton was known as a catalyst for economic improvement for the community. Among other awards, in 1988, he received the George Washington Honor Medal for recognition of his contribution to the education of the youth in the community.

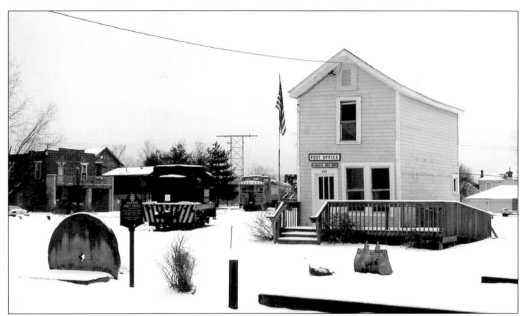

At 222 Gilman Avenue stands the Civil War-era Harmar Post Office. The Harmar Post Office was in operation from 1864–1885. Its original home was next to Harmar Tavern. During the flood of 1898, the Post Office floated into the middle of Maple Street. After waiting a few days, the impatient postmistress swept out the building and conducted business until two hours later, when crews with teams of horses pulled the Post Office back to its foundation.

Born in Marietta on December, 27, 1932, Jerry Barker Devol devoted his life to learning, teaching, and sharing his passions with others. Mr. Devol graduated from Marietta College in 1959 and did post-graduate work at Ohio State University. He taught at Marietta High School and Washington County Vocational School. Mr. Devol also worked as a draftsman in pipe fabrication at Dravo Corporation from 1956–1990. As John Briley, former director of the Campus Martius Museum, noted, Jerry was the historian of the Marietta area. Anything you wanted to know about Marietta and its past, you could find out from Jerry. Mr. Devol's photograph collection, gathered over the years in trips to antique shops, yard sales, and auctions continues to this day to impress those fortunate enough to do onsite research in Marietta.

# BIBLIOGRAPHY

Andrew R. L Cayton and Paula R. Riggs. Robert Frank Cayton, Ed. *City Into Town: The City of Marietta, Ohio, 1788–1988*. Marietta: Marietta College Dawes Memorial Library, 1991.

*Art Work of Washington County*. Chicago: W.H. Parish Publishing Co., 1897.

Chandler, Glen. *Memories from Yesteryear of Washington, Morgan & Noble Counties*. State College, PA: Jostens Commercial Printing and Publishing, 1994.

Cottle, Elizabeth Stanton Ed. *The American Association of University Women, A Window to Marietta*, 2nd Ed. Marietta: Richardson Printing Company, 1996.

Horton, A.H. and H.J. Jackson. *The Ohio Valley Flood of March-April, 1913*. Washington: Government Printing Office, 1913.

Lake, D.J. *Atlas of Washington County*. Philadelphia: Titus, Simmons, and Titus, 1875.

Strout, Nancy. *The Way We Were: Photographs of Washington County, Ohio 1900–1935*. Marietta: Richardson Printing Corporation, 1977.

Washington County Historical Society, *Washington County Ohio to 1980*. Dallas: Taylor Publishing Co., 1980.

Way, Frederick. *Way's Packet Directory, 1848–1983*. Athens, Ohio: Ohio University Press, 1983.

Winegardner, Carl T. *A Historical Account of B&O Rail Lines 1830–1989*. Heath, Ohio, 1998.